BARROW-IN-FURNESS REFLECTIONS

Gill Jepson

Dedicated to Harry, my love and my life partner

'Sometimes you never know the value of a moment until it becomes a memory'

Dr Seuss

First published 2023

Amberley Publishing
The Hill, Stroud, Gloucestershire, GL5 4EP
www.amberley-books.com

Copyright © Gill Jepson, 2023

The right of Gill Jepson to be identified as the Author
of this work has been asserted in accordance with the
Copyrights, Designs and Patents Act 1988.

ISBN 978 1 3981 0434 1 (print)
ISBN 978 1 3981 0435 8 (ebook)

All rights reserved. No part of this book may be reprinted
or reproduced or utilised in any form or by any electronic,
mechanical or other means, now known or hereafter
invented, including photocopying and recording, or in
any information storage or retrieval system, without the
permission in writing from the Publishers.

British Library Cataloguing in Publication Data.
A catalogue record for this book is available from the
British Library.

Typesetting by SJmagic DESIGN SERVICES, India.
Printed in Great Britain.

Introduction

This book gave me the chance to reprise my first book in the Amberley series and capture even more changes which have occurred since it was published. The level of change in some cases is quite staggering and shows how quickly places develop in modern times. This emphasises how important visual records are, as often they are the only evidence of what went before. Some of the pictures are of iconic views of the town, but I have been able to acquire new 'old' pictures which are not as familiar. This was possible with the expert help of Sue Benson at Barrow Archives once again, with her vast knowledge of the various photographs available there.

The town at present is in decline, with many long-standing businesses and shops leaving. This is sad but local groups and the council, assisted by government funding, are attempting to breathe new life into the town and rethink how the buildings are used. A heritage grant has been given to revive Duke Street which was one of the key commercial streets and has many interesting buildings requiring conservation and care.

It has been a difficult time for most towns, Barrow not excepted, economic difficulties and decline added to by the effects of the Covid-19 pandemic. It can be very disheartening to walk around what was once a thriving busy town, to discover empty and abandoned buildings, vandalism and graffiti. It is hard to see what can be done to reverse this decline, but one can only hope that a new purpose and life is developed soon. Maybe we must completely reimagine what our town should be and what it should look like.

As we move into a new era, which sees the town lose its Borough status in exchange for a new unitary authority, one wonders how the town fathers would regard this. It is unclear whether a town council will be retained, one would hope so, to give the people of Barrow a distinct voice. The magnificent town hall must continue to have a community function and not just become a shadow of its former self and as with other buildings in town, there needs to be a repurposing and innovative attitude to their continuance.

We have a most remarkable town, with some iconic buildings and these must at all costs be protected; quite often we do not appreciate what we have until its gone. There is hope with the new contracts gained by BAE which will increase employment in the town and hopefully inject cash and pride back into it. We will have to see what happens and continue to celebrate and record this unique northern industrial town and its interesting history. As always, we would do well to look to the town's motto 'Semper Sursum' or 'always rising' and remember the efforts of people like Ramsden, Schneider, Buccleuch and Devonshire to inspire us to carry this town into a new, more sustainable era.

Gill Jepson 2022

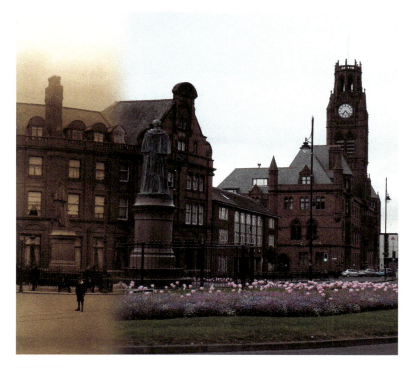

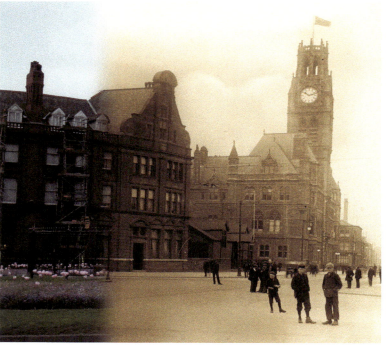

Schneider Square

The view across Schneider Square is somewhat different to that depicted on the Victorian postcard. This area was part of the original village, although no buildings exist from before the 1840s. It is dedicated to one of the town fathers, Henry Schneider, the mineral speculator and iron mine owner, who helped to generate an industrial revolution in the area. His statue dominates the space, but its orientation now faces the town hall, instead of Michaelson Road. The tramlines have gone, and the statue sits in the middle of a large roundabout opposite the Majestic Hotel which is unchanged in the background.

Barrow-in-Furness Town Hall, Completed 1887

Barrow grew from a small village of 200 people to a population of over 40,000 in less than forty years. It was made a Borough in 1867 and its prominence as a town grew. The town hall was built between 1882 and 1886 in the Gothic style under architect WH Lynn. It is still an impressive building and stands at 50 metres high. It currently houses the local council but is soon to undergo a huge change when the new unitary authority takes over. It will mark the end of over 150 years as a Borough.

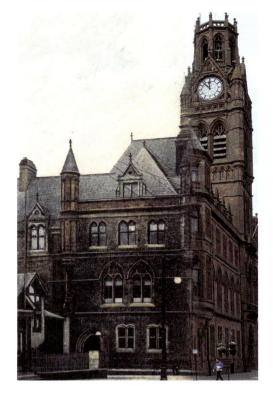

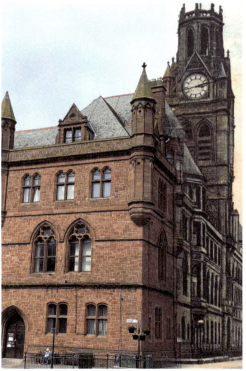

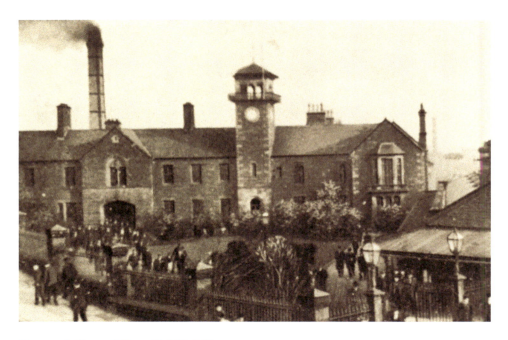

Furness Railway Offices, Rabbit Hill

Furness Railway Company was the catalyst for the development of the town, bringing opportunity and work. The railway developed from just freight to passenger services gradually and it administered a large business interest. The company had an illustrious board, including the Dukes of Devonshire and Buccleuch, Henry Schneider and James Ramsden. They had high ambitions for the town and were keen to create docks, steelworks and shipbuilding, making the town an important centre of industry. The offices sadly have not survived.

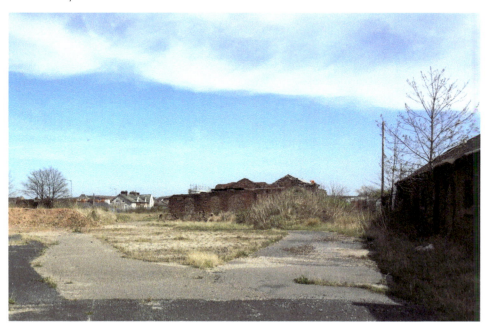

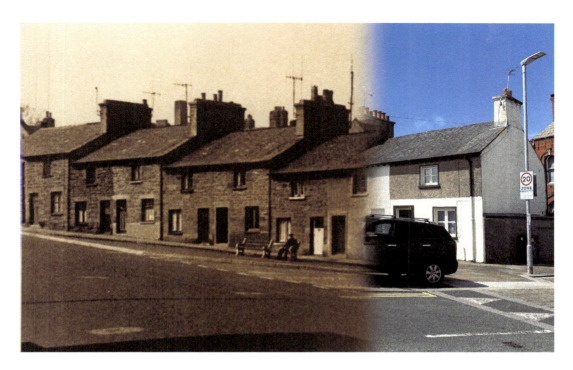

Railway Cottages, Rabbit Hill
These cottages are some of the oldest buildings in the town. They are built from local red sandstone and are placed close to the Furness Railway offices. These were originally built for the railway workers and were next to the school at the top of the terrace. Rabbit Hill is the old name for the hill which is now part of Salthouse Road. (Photo courtesy of Barrow Archives)

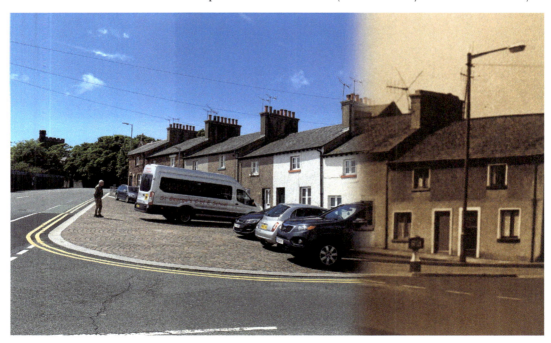

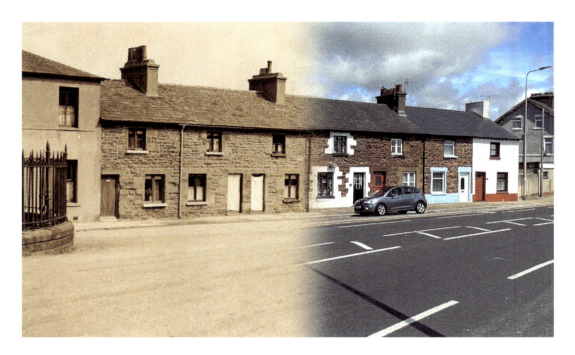

Railway Cottages, Salthouse Road
The terraced cottages continue beyond the junction of Rawlinson Street and are in the same style as the others. They are attractive and have been enhanced by new paving in front of the buildings. The chimney flue adjacent to the school which used to vent the fumes from the forges and foundries at the engineering works was demolished in 1938. Both rows of cottages are still occupied and have been enhanced by paving and parking in front of them. (Photo courtesy of Barrow Archives)

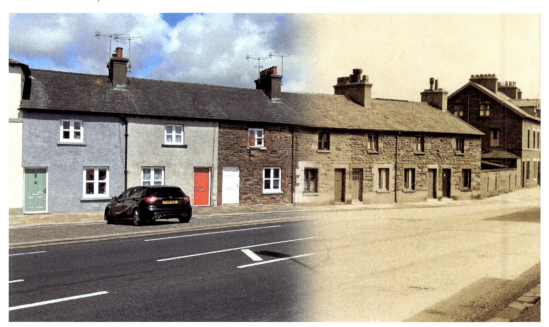

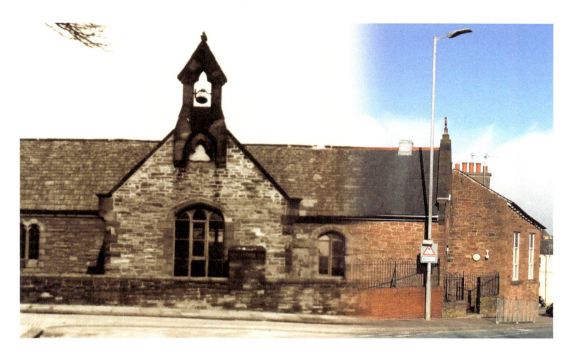

St George's Primary School
This is the oldest school in Barrow and was originally built as an engineering training college for the Furness Railway Company. It has undergone many changes and was recently completely remodelled to accommodate the children in a more appropriate way. It has retained much of its character but has been adapted internally to provide better spaces for the children. It is easily recognisable despite the alterations. (Photo courtesy of Barrow Archives)

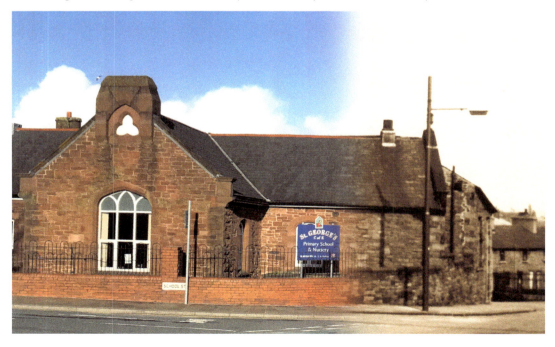

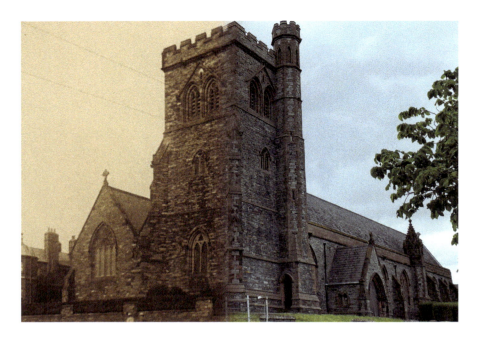

St George's CE Church

This church was consecrated in 1861 and was the first Anglican church in Barrow. It is built from slate from Burlington Quarry, and local sandstone in the Gothic style. The key patrons were Devonshire and Buccleuch, and it was built at the suggestion of Ramsden. It became the municipal church and is still used for civic services. Ramsden was responsible for the chapel (named after him) and it is a testament to his own self-esteem. He had carved heads of himself and his wife inserted either side of the altar and there is a Gothic sedilia reserved for dignitaries. Additionally, he had his own entrance built so he could access the church privately.

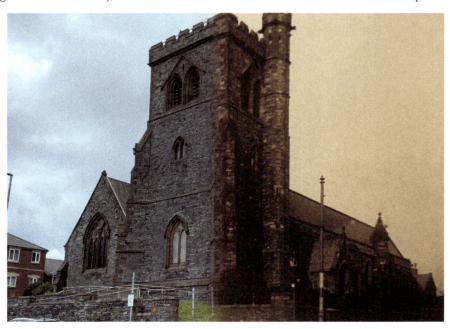

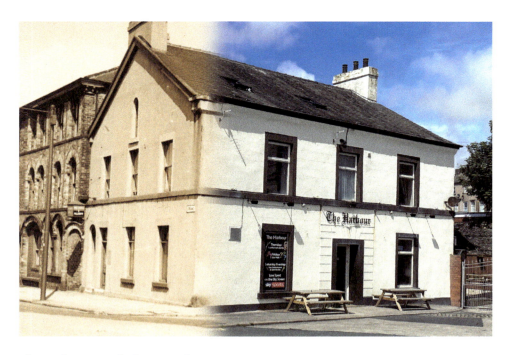

The Harbour Hotel, The Strand
Now known as the Harbour Inn, this public house was established on the Strand in 1850. It is Grade II listed and it once formed part of the new town centred around the original railway terminus on St George's Square. This was meant to be the centre, but the direction of influence drifted when the second railway station was built by Abbey Road and what is now Holker Street. It has undergone a recent regeneration and is regaining some of the popularity it once had. (Photo courtesy of Barrow Archives)

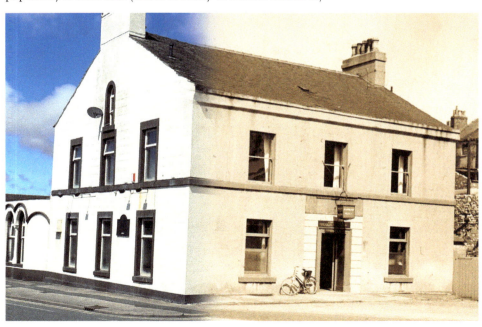

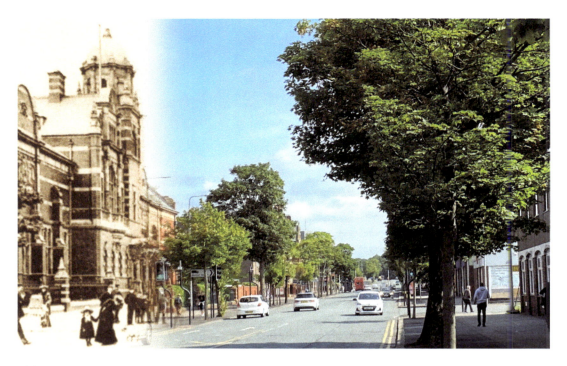

Abbey Road looking East

The view from Ramsden Square up Abbey Road shows the old tram system, which lasted from 1885 until 1932. It began as a steam system but was later developed as an electric system. It had around 6 miles of track and connected various parts of the town. The large width of Abbey Road accommodated it comfortably as it was designed as a grand tree-lined avenue culminating at Ramsden Square.

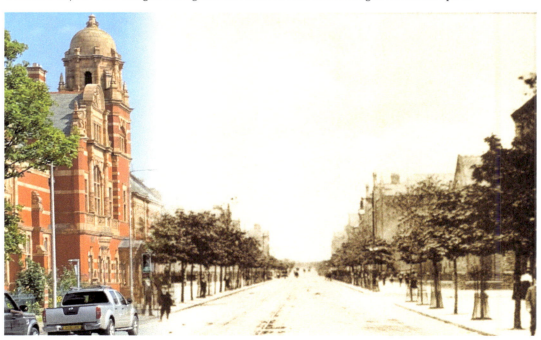

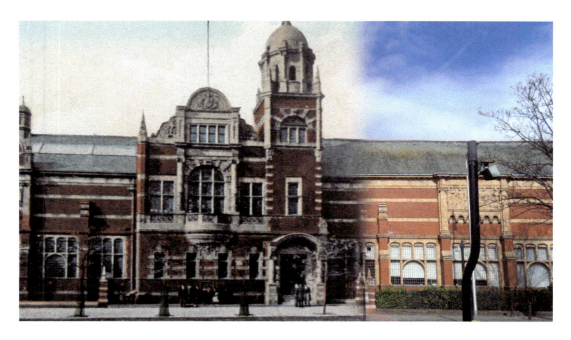

Barrow Technical School, Abbey Road

Now known as the Nan Tait Centre (named after a local councillor), the Technical School is a beautiful red-brick building which was built at the turn of the twentieth century. Mrs Albert Vickers laid the foundation stone on 26 May 1900 and the building became a training school for the future apprentices and workforce of the Vickers Shipbuilding Company. It endured until the 1950s and was then replaced by Thorncliffe Technical School and Howard Street College. It fell into disrepair but was saved in 2000 and refurbished as an arts facility and offices for Cumbria County Council.

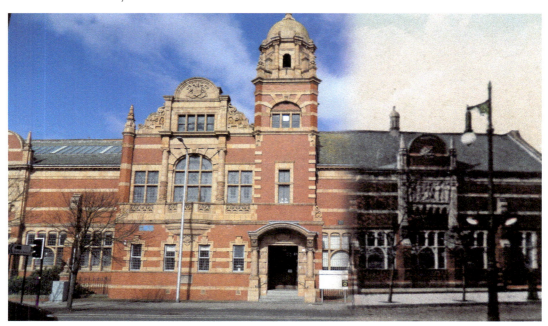

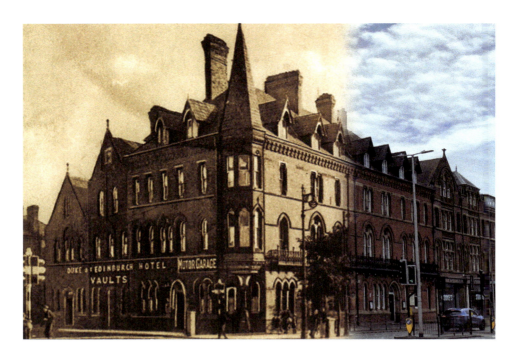

The Duke of Edinburgh Hotel

Built close to the main railway station in 1871, the Duke of Edinburgh hotel reflected the growth and prosperity of the town. It was built in the Gothic style and is an imposing building positioned close to the town. In its heyday it attracted some illustrious guests including DH Lawrence, Clark Gable and Charlie Chaplin. Its fortunes diminished after the Second World War, and it became dilapidated; however, it was rescued by Lancaster Brewery in 2006 and remains a popular hotel and eating place.

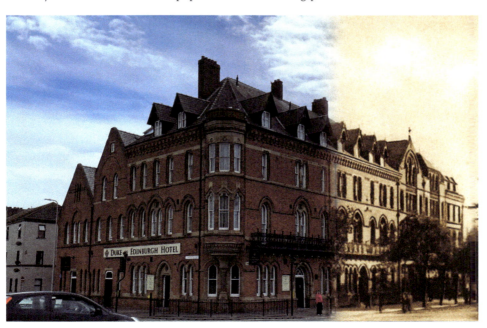

St Mary's RC Church, Duke Street

The first Roman Catholic church was designed by the renowned architect EW Pugin and completed in 1867. It was built in response to the influx of Irish workers to the town and heralded a return of Catholicism to the area. It can seat 800 people and is an ornate and colourful building. A school was built in 1872, which later developed into two schools in different parts of town. Its spire was conserved and repaired in 2015 supported by the Heritage Lottery Fund. It remains an important centre for the Roman Catholic residents of the town.

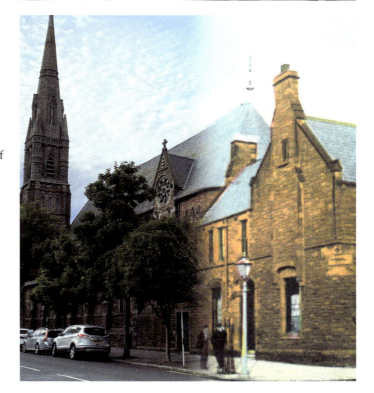

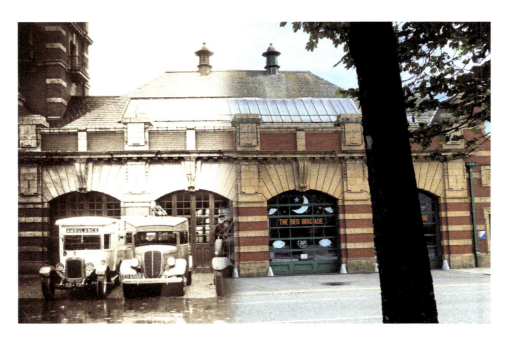

The Old Fire Station, Abbey Road

This state-of-the-art building was built in 1911 and incorporated space for motor appliances. It was a formalisation of the voluntary service which had been established in 1866. It originally included the stationmaster's house and accommodation for two drivers. The building now houses the 'Bed Brigade' store and offices above, while the fire service now operates from premises on Phoenix Road, closer to the main A590 road. (Photo courtesy of Barrow Archives)

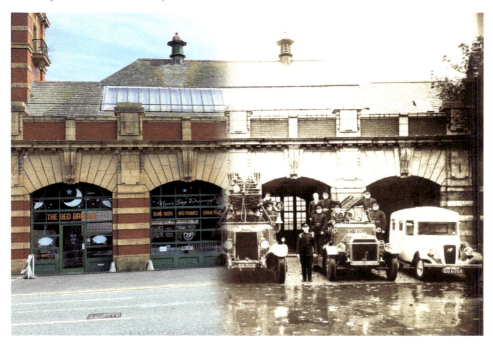

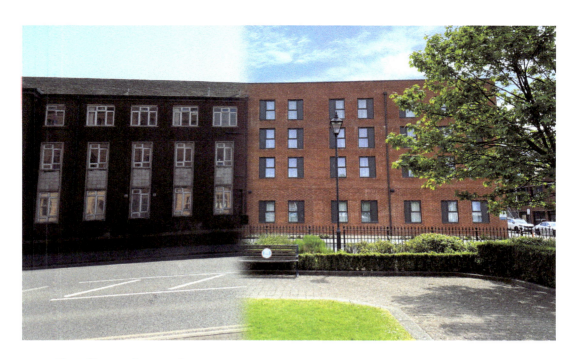

The Police Station, Market Street

Municipal and service buildings have come and gone over the years and the police station is no exception. It was built in 1958 and had a magistrates' court attached. It was typically 1950s in design and had a time capsule buried beneath it, suggesting that the builders anticipated a long life. Instead, it was judged to be inadequate in less than sixty years, being replaced by a large modern building in St Andrew's Way on the outskirts of town. The site is now occupied by Holiday Inn Express which is less obtrusive than anticipated and is now part of the town landscape.

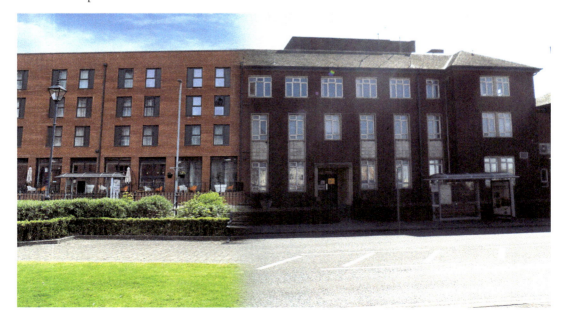

The Old Magistrates' Court, Duke Street
Adjoining the 1950s police station was the Magistrates' Court. This was demolished at the same time as the police station and a new building replaced it on the site of the old baths on Abbey Road. The site of both the police station and the Magistrates' Court has been replaced with the hotel and sits between the older Majestic Hotel and the town hall.

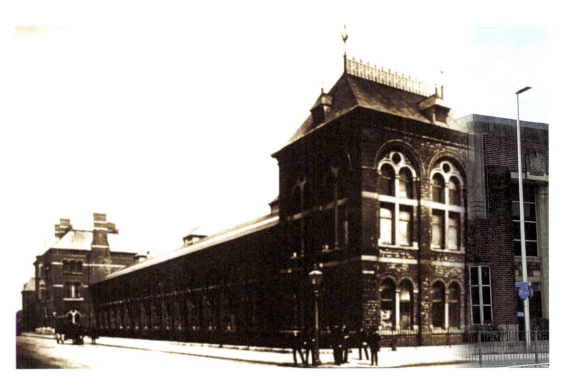

The Jute Works, Abbey Road

James Ramsden was responsible for establishing the Barrow and Calcutta Jute Works in 1870, partly to diversify industry but also to provide employment for 2,000 women. It was designed by Paley and Austin and had its own railway station connecting it to the docks, cornmill and steelworks. It prospered for a short time but eventually competition from Indian and Dundee jute production overcame it. It was replaced by John Whinnerah Institute and Lakeland House and latterly a retail site. (Photo courtesy of Barrow Archives)

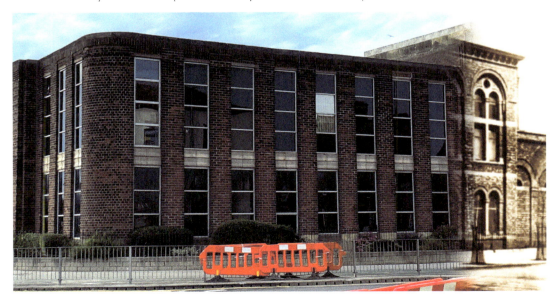

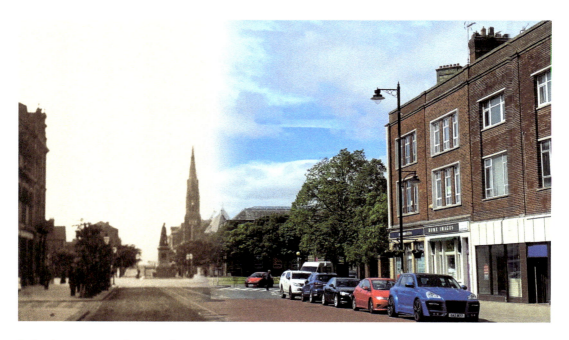

Duke Street, towards Ramsden Square

The bottom half of Duke Street looks slightly different to the view today, with fewer buildings. Sir James Ramsden's statue is visible and St Mary's Church stands in the distance. There are numerous small shops displaying their sun canopies, and tramlines can be seen in the centre of the road. Duke Street was part of the commercial sector, having various businesses, banks and even a stockbroker. The commercial centre drifted to the main street in town and Dalton Road has many of the banks previously situated along Duke Street. (Photo courtesy of Barrow Archives)

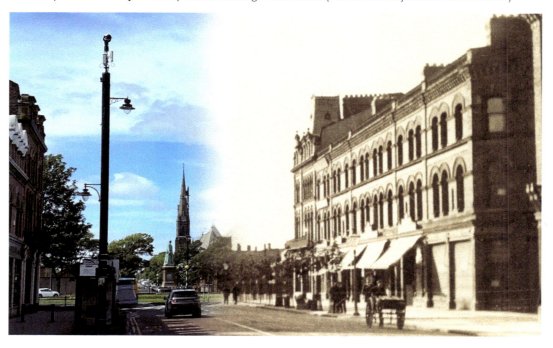

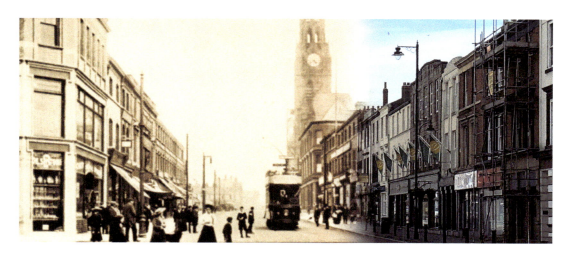

Duke Street South

A busy scene greets us in the old picture, with pedestrians, trams and shops. Duke Street is much quieter these days and cars have replaced the trams. The town hall stands at the top of Duke Street and confirms its importance. Small businesses line the street, and it appears to be thriving. Nowadays, it comprises a few shops and businesses but also numerous empty buildings. However, funding to conserve this important piece of Barrow's heritage has been acquired, which should ensure its existence well into the future. (Photo courtesy of Barrow Archives)

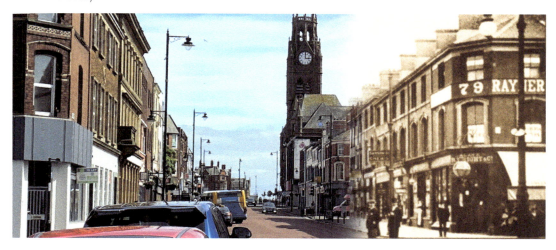

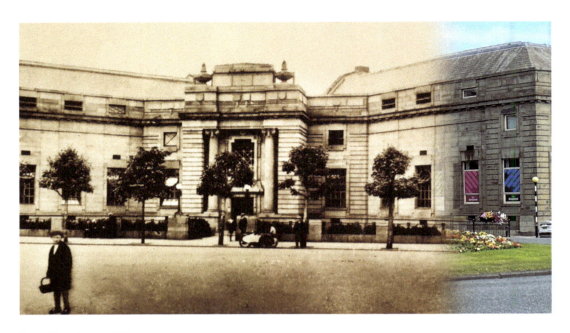

Ramsden Square Library
Ramsden Square holds the statue of Sir James Ramsden, the first mayor of Barrow and a founding father. Behind him is the magnificent Public Library, built in 1915 but not completed until 1922, delayed because of the war. It is Beaux-Arts in design and has changed little externally. It celebrated its centenary in October 2022, following extensive refurbishment and modernisation, remaining a centre of the community today. (Photo courtesy of Barrow Archives)

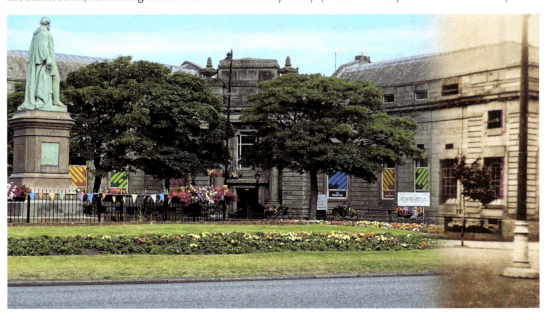

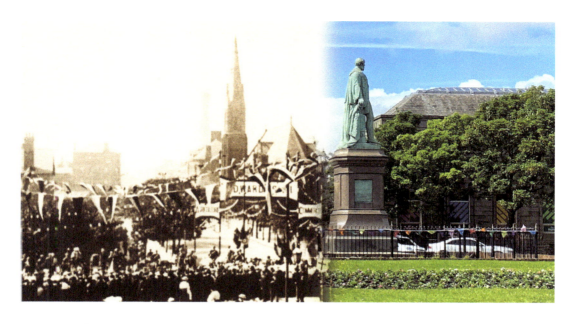

Ramsden Square and Coronation Celebrations
The celebrations for the accession of Edward VII in 1902 were held countrywide. Ramsden Square is packed with people dressed in their best clothes for this important civic occasion. It brings the town into the next era and away from its Victorian origins. The square is quite different to today, minus the library which dominates it now. In the modern photo we can see some bunting ready for the Platinum Jubilee celebrations for Elizabeth II, great-granddaughter of Edward VII. (Photo courtesy of Barrow Archives)

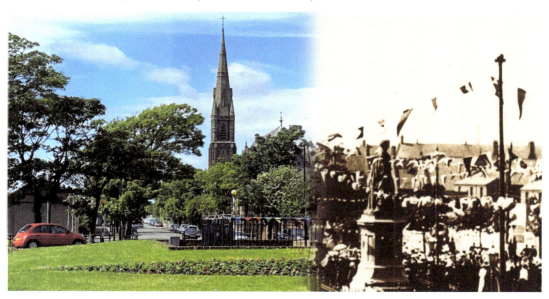

23

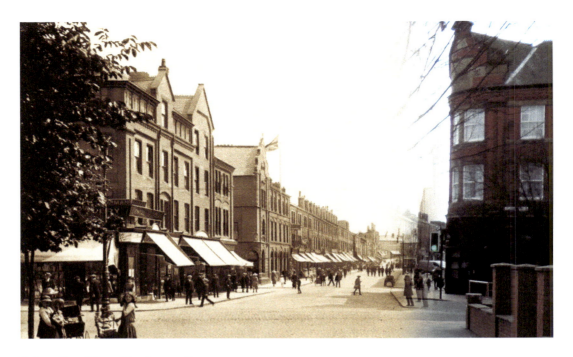

Dalton Road from Hartington Street
The main shopping street was Dalton Road, and we can see how vibrant and busy it used to be. Many small shops are noticeable, and the Co-operative building is visible to the right. Trade has diminished over the years and the town has lost some of the mainstay businesses, like Marks and Spencer, the Co-op and Boots (now in Portland Walk). Sadly, they have not been replaced and despite the efforts of the local business community things have not improved. (Photo courtesy of Barrow Archives)

24

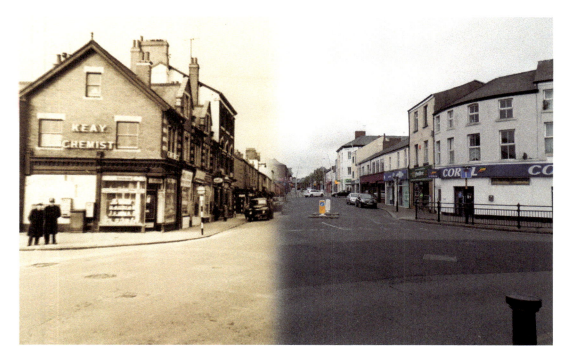

Dalton Road (top)
The 1950s view of Dalton Road looks towards what was the junction of Forshaw Street and Crellin Street. Again, it's full of shops and it has not yet become a pedestrianised street. It seems a shame that the street has declined so much, although some businesses have stayed the course for example, Heaths Book and Toyshop. (Photo courtesy of Barrow Archives)

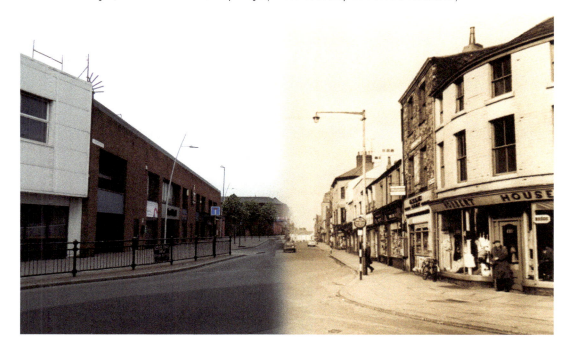

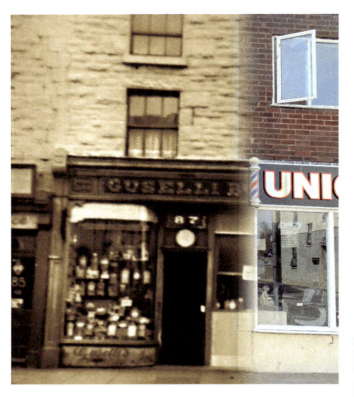

Guselli's, 87 Dalton Road
One of the numerous Italian ice cream shops which operated in the town is Guselli's. The family opened their first ice cream parlour in 1900 and the business went from strength to strength. It was a popular café during the 1950s and even had a jukebox. (Photo courtesy of R. Guselli)

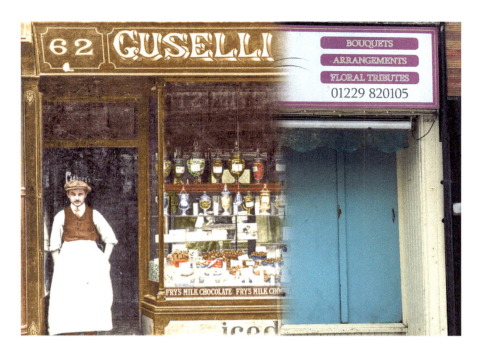

Guselli's, Cavendish Street
The Guselli family originated in Italy and emigrated to Britain, eventually arriving in Barrow. They were well loved and embedded themselves into the community. The shop became a popular coffee shop and ice cream parlour. Cavendish Street had many small businesses and though some buildings have changed it is easy to locate them even today. (Picture courtesy of R. Guselli)

Hairdressers, Friars Lane

On the outskirts of Barrow many small businesses thrived and as leisure and greater financial flexibility grew, hair salons increased in the 1950s and beyond. This salon was above the barbers and served the local community. The shop has a dwelling next door and is on a main thoroughfare with other small shops. It is continuing its purpose as a salon and now offers a comprehensive beauty experience.

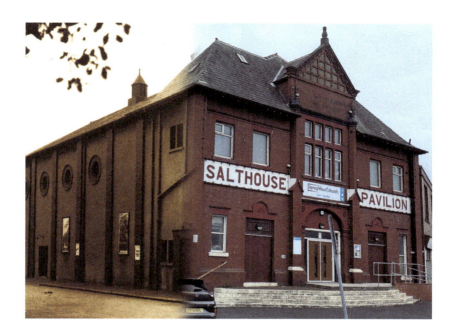

Salthouse Pavilion

There was a flurry of theatre and cinema building in the early twentieth century, spread across the town. The Salthouse Pavilion in Salthouse Road was built in 1920 for those living in the suburbs. This building has escaped demolition and is thriving in its third incarnation, this time as a church. It was quite luxurious and had a small stage and a balcony, however it did have flaw in its design. Rather than the usual staggering of seats to allow the audience a clear view, the seats were placed in straight lines. When it was closed in 1959 it re-emerged as the new popular entertainment bingo. This continued until 2012 when it was sold to Spring Mount Christian Fellowship. External features have remained the same, but it has been redesigned to suit the purpose of a church and community centre. (Photo courtesy of Barrow Archives)

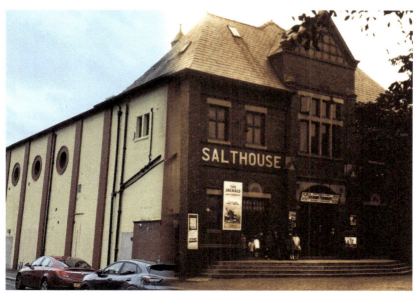

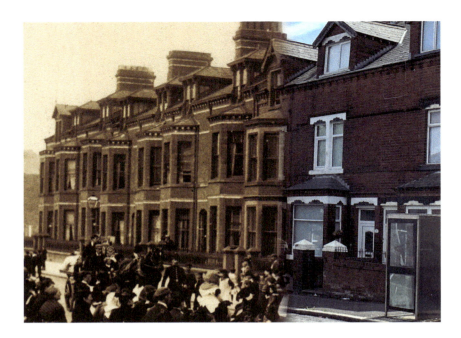

Bicycle Parade, Mafeking Day
Parades were often popular and celebrated many events. This one is for Mafeking Day which celebrated the relief of Mafeking in South Africa during the Boer War. Colonel Robert Baden-Powell led the British to victory and became a national hero. The parade commemorates this event which happened in May 1900. The location is Hartington Street and shows a middle-class residential area. Some of the crowd is quite well dressed. The street is semi-residential these days, but also accommodates doctors, dentists and other businesses. (Photo courtesy of Barrow Archives)

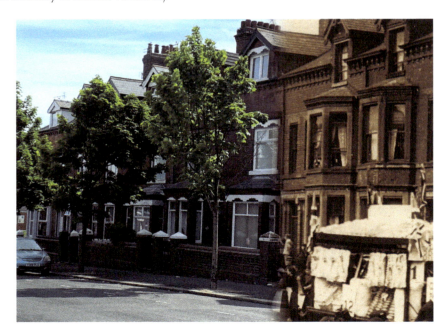

Barrow Park, 1918
As the town established and developed there was a need for leisure facilities and Barrow Park was created for the local people. It was designed by Thomas Mawson in 1908 and is a magnificent spectacle covering 45 acres. The postcard shows an embryonic park looking towards Yarlside across the fields. The view takes in the bandstand, a shelter and the newly formed lake and green fields stretch for miles, unlike today when few of these features are visible and houses cover the countryside.

31

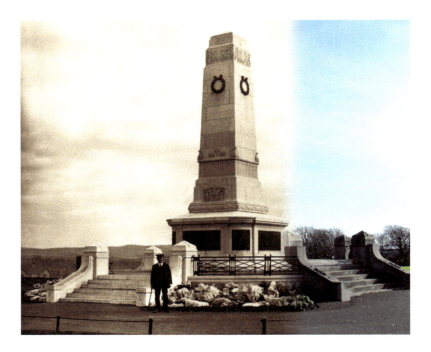

Unveiling the Cenotaph, 1921
Erected in 1921 to commemorate the town's war dead, the cenotaph sits on top of the hill and is a visible landmark. It is central to the Remembrance Day ceremony even today and many more names were added following the Second World War. The old picture shows the park keeper standing in front of the cenotaph, and the number of people recorded on the monument reflect the effect of the huge losses on the local community. (Photo courtesy of Barrow Archives)

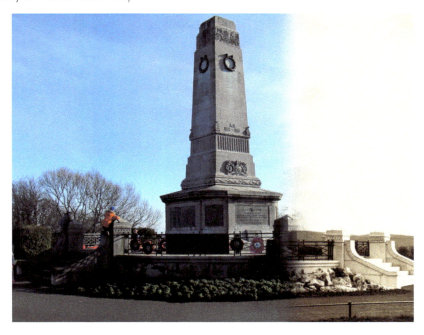

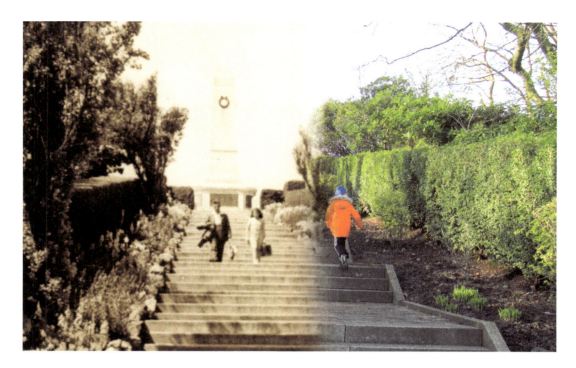

The Cenotaph Steps
Virtually every child in the town will, at some time, have run up and down these steps to count them and discovered there are ninety-nine. It is an impressive vista and the view from the top is panoramic. It is understood that the hill originally had an Iron Age fort at the top and was known locally as Black Castle. (Photo courtesy of Barrow Archives)

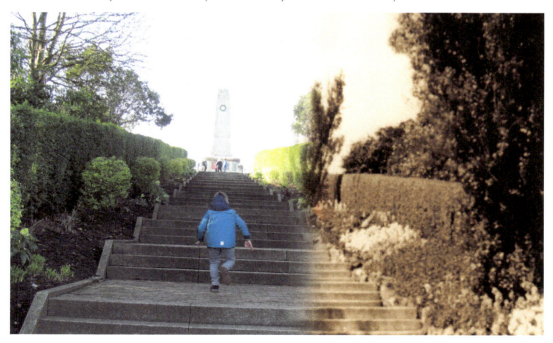

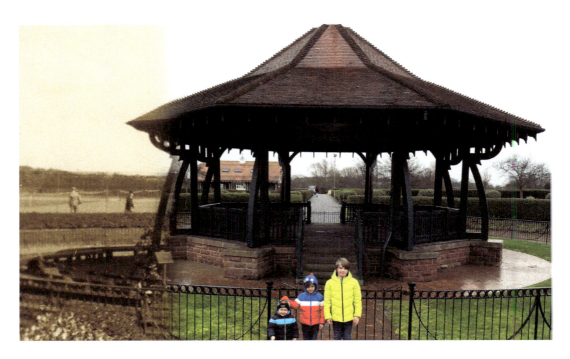

The Bandstand

Although at first glance the bandstand looks the same, on closer inspection changes can be seen. The stand is still used for musical events though perhaps not as often as in the past. Tennis courts have given way to a play park, though the bowling green is still operational. (Photo courtesy of Keith Wallwork)

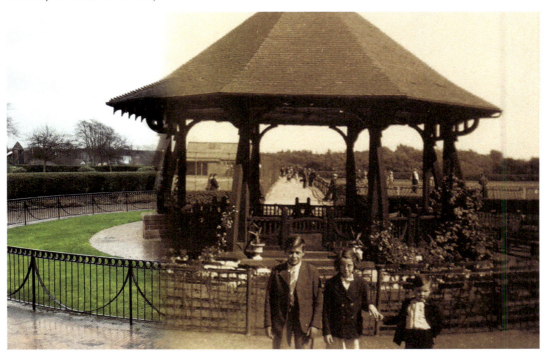

St Luke's Church, Roose Road
Now demolished, St Luke's was one of four churches established in 1878 during the growth of the town. They were named after the Evangelists Matthew, Mark, Luke and John and were initially temporary structures. This one was built in 1964 and following dwindling congregations and building issues it was demolished and the land sold, now accommodating sheltered housing.

Risedale Secondary School, Risedale Road
In 1902 local authorities were given control of the education system via the Education Act. Risedale was built in 1926 and specialised in commercial and secretarial skills and a good general education. It survived until 1979 when the comprehensive system came in. Children were dispersed to other schools and the land sold off. A supermarket now sits on the site and is convenient for those who do not want to go into town or to the shopping parks on the outskirts. (Photo courtesy of Jennifer Foote)

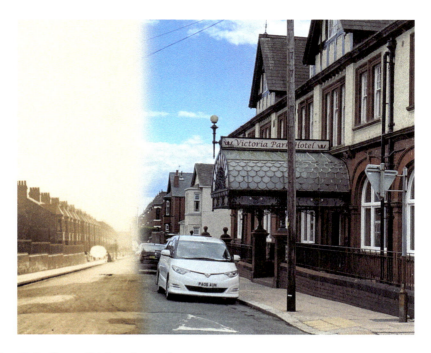

The Victoria Park Hotel, Victoria Road
This grand hotel was built around 1900 at a cost of £5,000 and was a smart hotel with all modern conveniences. It sported a bowling green, a ballroom and bars and comfortable accommodation for guests. It was a popular venue for weddings and celebrations and was fondly known as 'The Vic'. The building is now serviced apartments and has ceased to be a hotel. (Photo courtesy of Barrow Archives)

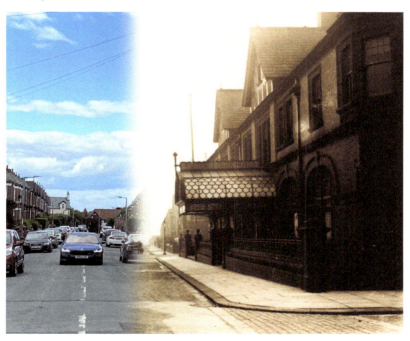

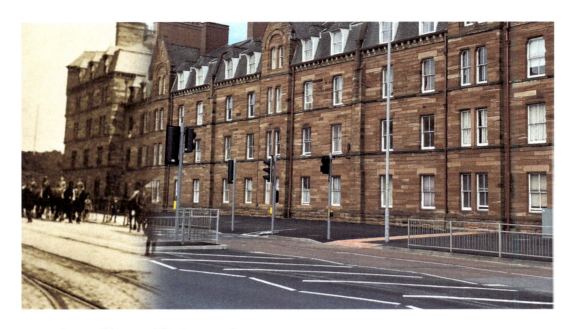

Devonshire Buildings, Michaelson Road
Purpose built for the workers of the shipyard by Paley and Austin, Devonshire Buildings are in the style of the Glasgow tenements. They provided decent accommodation with all modern conveniences of the time and were necessary for the rapid influx of workers to the town in the 1870s. They are Grade II listed buildings made from local sandstone and are still in use today. Holker Estates (run by the Cavendish family) have recently improved them, and they provide suitable accommodation for the twenty-first century. The parade of soldiers are recruits for the First World War marching to the training camp.

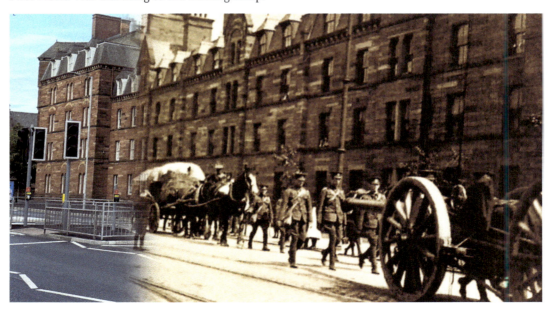

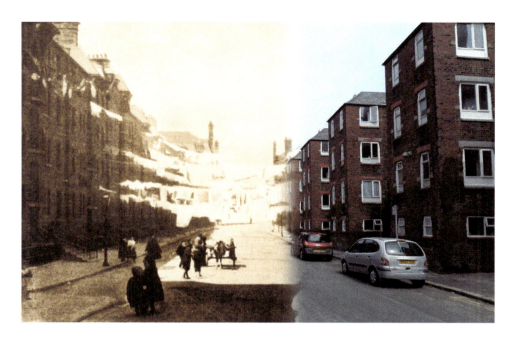

Ship Street, Barrow Island
Tenements were a cheap and efficient way of providing housing for the workers and numerous blocks were built. They were built in the 1880s again by Paley and Austin of Lancaster, preferred architects of the town at this time. The buildings have suffered from neglect over the years and have attracted some social problems, but the area has been much improved in recent times. Landscaping and refurbishment have been undertaken to provide a more pleasant environment for the residents. (Photo courtesy of Barrow Archives)

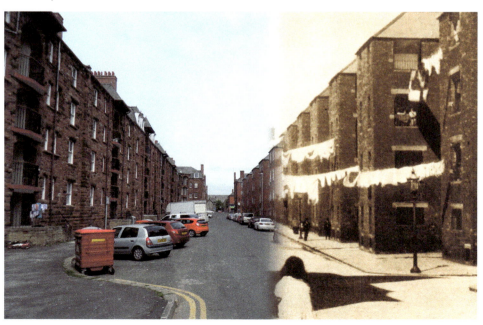

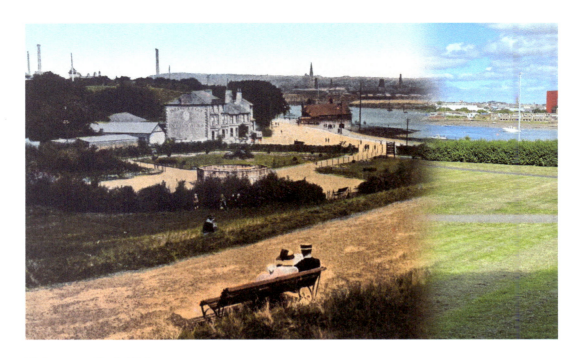

Vickerstown Park, Walney

This tinted postcard shows the new park provided for the residents of Vickerstown, the new housing estate for shipyard workers. The Ferry public house can be seen and the view across the channel shows the industrial face of the town. The ferry itself is visible and it was necessary until the bridge was built in 1908. The church spires that can be seen are St James' and St Mary's churches. The view is identifiable today but many of the industrial buildings have gone or have been replaced by others.

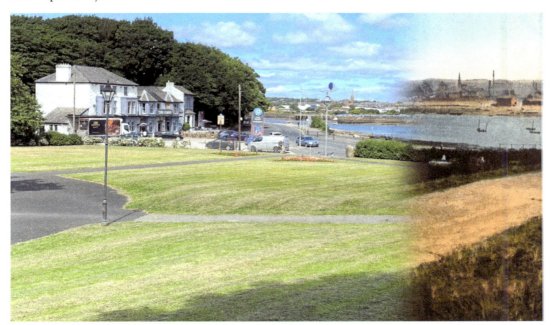

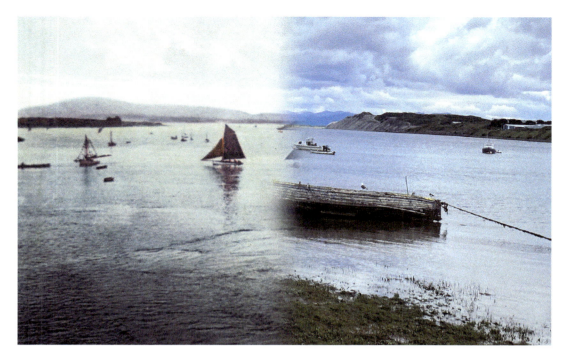

Walney Channel

The thin strip of water which separates Walney Island and Barrow has been a useful natural geographical feature. The shipyard has grown on Barrow Island and the landscape is dominated even today by industry. The channel opens into the open sea, and this is the reason the port grew. The system of docks unites the islands and connects the changing industries. The view to the north is very picturesque and shows the lake district hills in the distance.

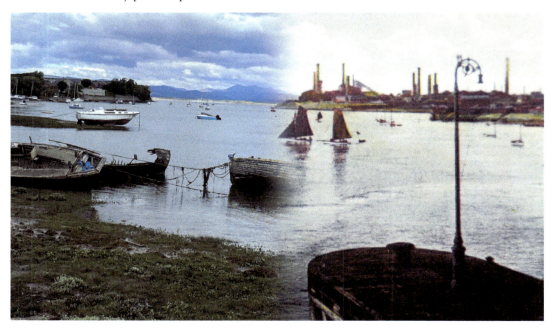

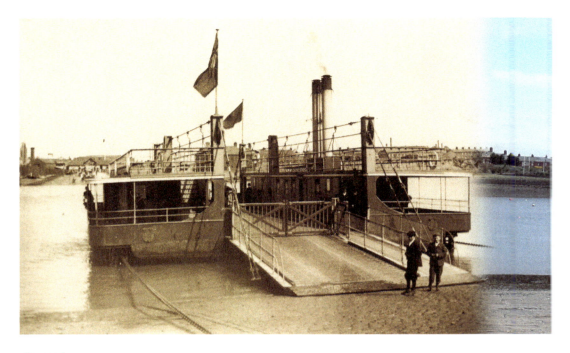

The Walney Ferry
Walney was an island which could only be reached by ferry, boat or over a ford at low tide across the sands until 1908 when a bridge was finally built. The Furness Railway Co. ran a steam ferry and smaller ferries were used as the passenger numbers grew. The cobbled slips on either side of the channel are still visible and the Ferry Hotel is named after it. (Photo courtesy of Barrow Archives)

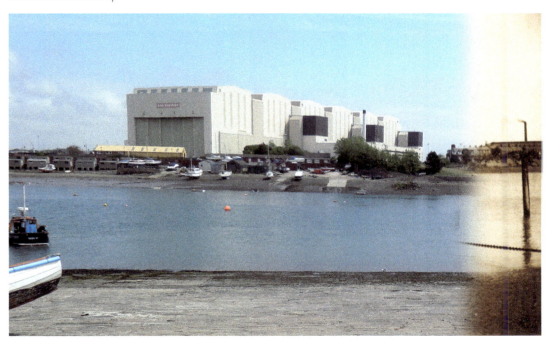

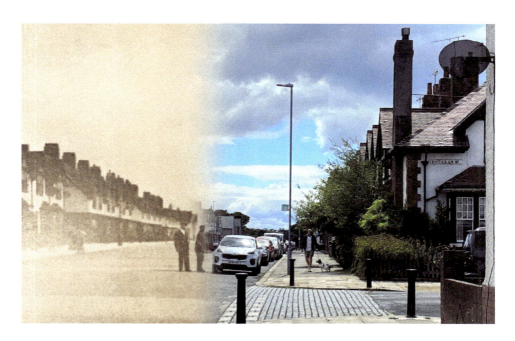

Powerful Street, Vickerstown

Worker accommodation was always an issue for Barrow as it grew and the companies who employed them were obliged to provide some. Vickerstown was built by Vickers Ltd and provided decent housing close to work. They ranged from plain terraced homes to larger homes with small gardens and were part of the ideal 'Marine Garden City' as it was termed. Changes have been minimal, and the houses are still popular places to live, though they are now privately owned. Vickerstown is distinctive with its attractive half-timbered style, and they heralded the growth of the community on Walney Island.

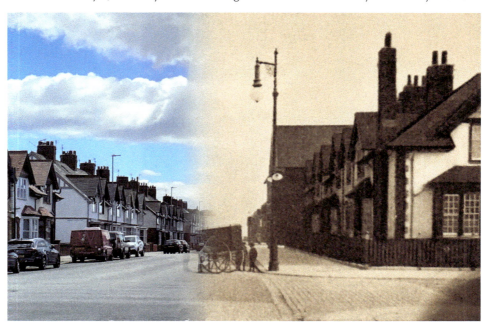

North Scale Village
This village is one of the oldest in the district and was originally an abbey grange. In the Civil War there was a brief skirmish when the Parliamentarians besieged the village. They finally abandoned it and the reprisals were severe by the opposing Royalists: all but the two houses belonging to Royalists were burnt to the ground. The house in the foreground is dated 1684 and has retained many of its original features.

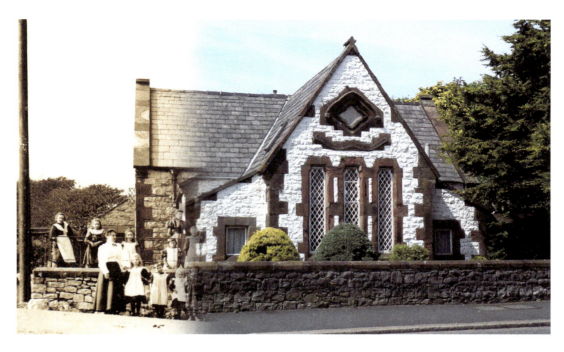

Walney School, 1898
Pupils in 1898 stand for their photograph in front of the school in its rural setting. It is a private house now and externally is little changed. Of course, it is no longer surrounded by countryside; instead houses surround it and it fronts a very busy road to Biggar Bank. (Photo courtesy of Barrow Archives)

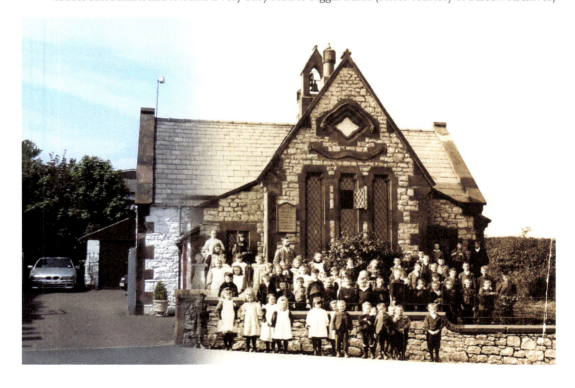

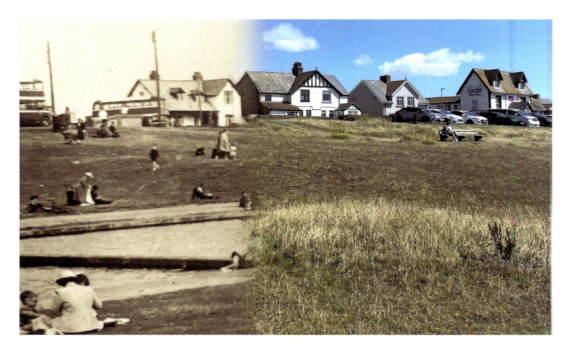

Biggar Bank, Walney

From the earliest days of the town, Walney has been a popular place for recreation. Originally farmland, it was bought by the council to provide recreational space for the town's people. The beach huts and pavilions have long gone but the beach is the same and the children still enjoy the sea and sand today.

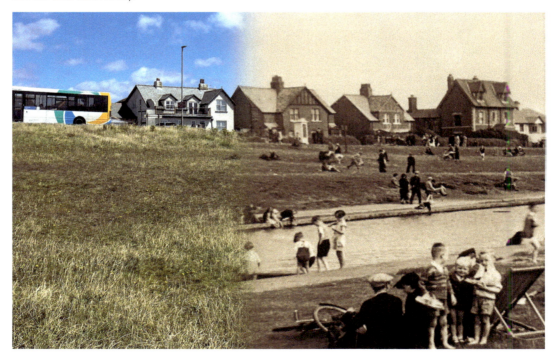

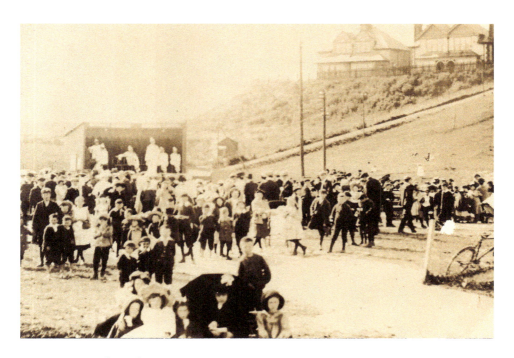

James Dunn Park, Walney
The need for a park arose with the creation of housing and this park was opened by Walney Estates in 1902. A pond and bandstand were added two years later in 1904. Barrow Council took over the park in 1915. The park hosted various events, including the popular Pierrot shows. An unusual entrance is marked by a huge boulder which is a glacial erratic brought down from Eskdale. This is a reminder that Walney is a huge murrain left by the glacier. (Photo courtesy of Barrow Archives)

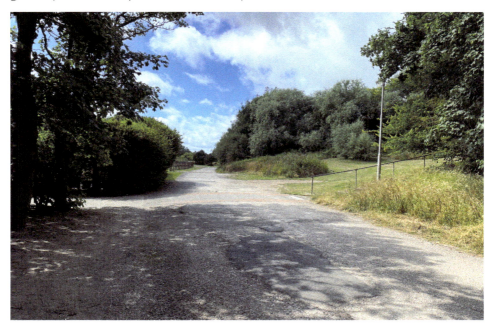

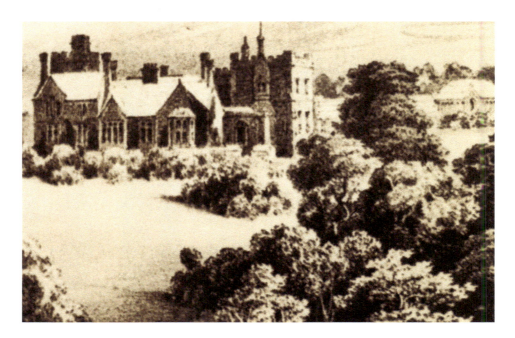

Abbotswood

Sir James Ramsden was rewarded with this grand house by his employers at Furness Railway Co. The house was Gothic in style and cost £2,000 to build. It had gardens, orchards and greenhouses and a sunken lane was created for staff use, to prevent them being seen by guests. It had its own railway siding for Sir James to take the train into town and he frequently held up the train being late. It was demolished by the council in 1961, replaced by an underground nuclear bunker. This too passed away and the area is now a wildlife area and recreation spot for the public.

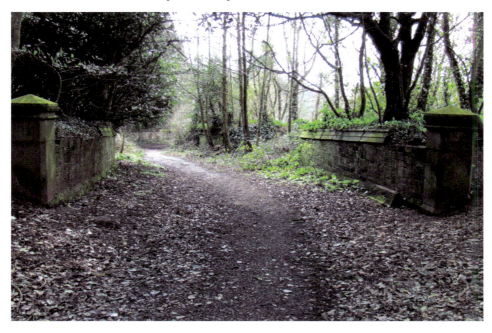

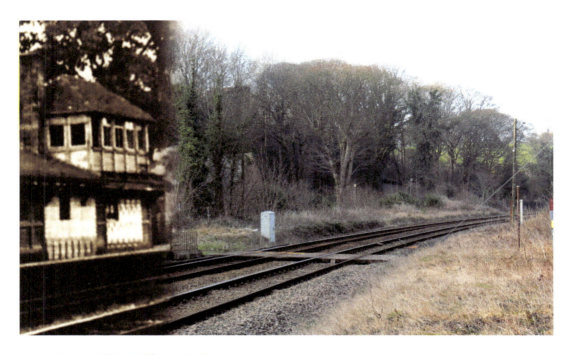

Furness Abbey Railway Station
Furness Railway Co. built the station at the abbey as part of the tourist offer. It provided access to the ruins and the splendid hotel which was popular with visitors. The station was disestablished in 1950 and little trace remains of the special siding which James Ramsden used.

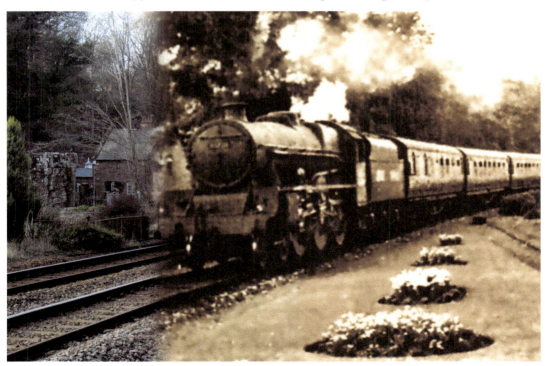

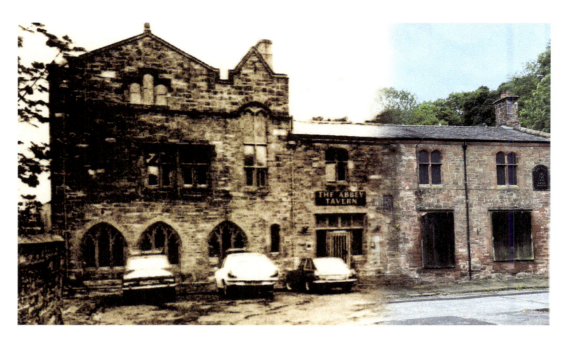

The Abbey Tavern
During the time when the station was operational, this building was a second-class refreshment room and ticket office. It is the only part of the range of buildings which comprised the hotel as well. It survived demolition and in the 1950s became a public house and restaurant. Sadly, although locals often tell how wonderful it was, its following diminished and it became empty for twelve years. English Heritage purchased it and are trying to find investors to bring it back to life. (Photo courtesy of Barrow Archives)

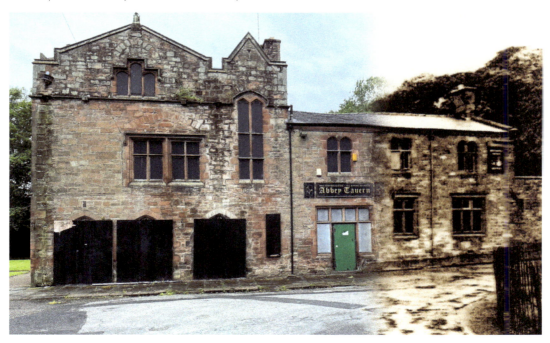

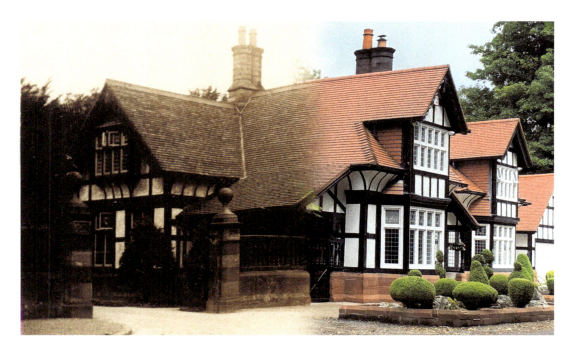

South Lodge, Abbotswood

Sir James Ramsden's butler's family lived in this lodge at the end of the main drive. The McGrory family are noted on the 1881 census, and it appears that the butler lodged in the big house itself. It is lucky to have survived the demolition which Abbotswood itself suffered. It has been extended and modernised in recent years, but the character has been preserved, nonetheless. (Photo courtesy of Barrow Archives)

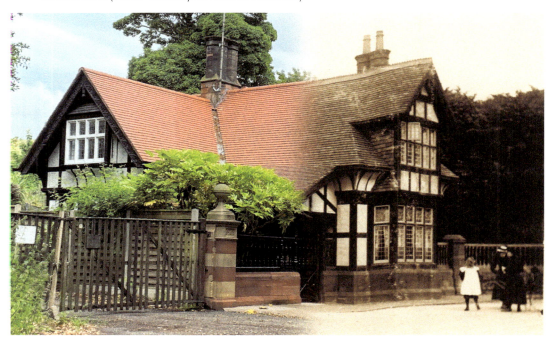

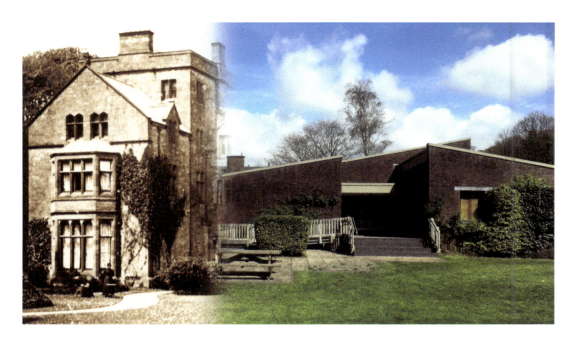

Furness Abbey Hotel

Post-dissolution there was a manor house built for the Preston family, incorporating some of the stone from the abbey and maybe part of the gatehouse as well. By the time the Cavendish family inherited the building it was rundown. Furness Railway purchased it in 1847 (it was owned by William Cavendish, Duke of Devonshire, who was also a director of the company). A grand hotel with thirty-six rooms was built and became part of the tourist offer for the railway. It had a ballroom, billiard room and public areas. It was expanded by **Paley** in the 1860s to link it to the new station. Following bomb damage in 1941 it fell into disrepair and was demolished, leaving only the tavern standing. (Photo courtesy of Barrow Archives)

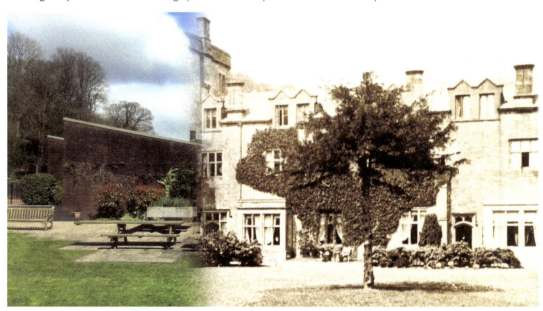

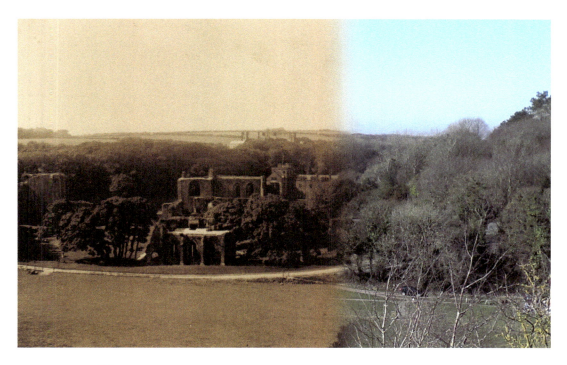

Furness Abbey
These images of the twelfth-century abbey show that some subtle changes have occurred over the years. Trees have been removed to reveal the buildings and, in the distance, woodland obscures the view. The iconic view is taken from the hill opposite, which is known locally as the amphitheatre. Red sandstone used to build Furness Abbey was acquired from this area and on either side of the monastery.

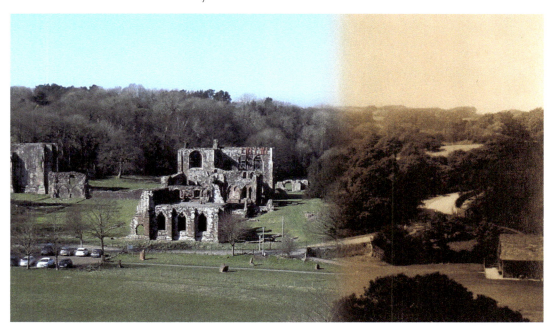

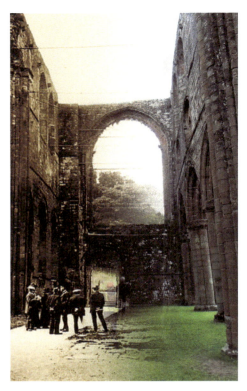

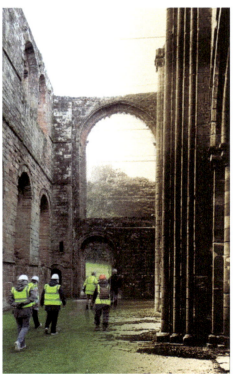

Northern Transept, Furness Abbey

Looking north to the main entrance to the transept we can see a tour of the abbey ruins almost a hundred years apart. The northern transept has suffered over the years from subsidence and movement, mainly due to the oak rafts which it was built on deteriorating. In the early picture metal rods can be seen supporting the masonry, but by 2021 the problem had been solved and the foundations corrected. The transept was altered during various periods and the original twelfth-century building replaced.

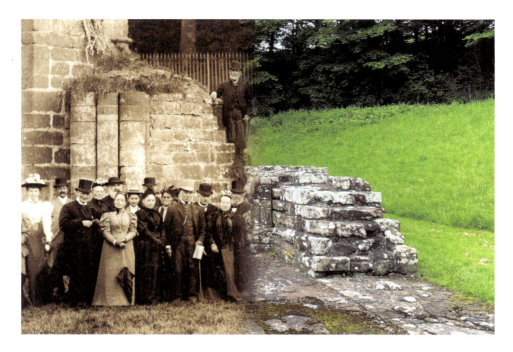

The West Tower Steps, Furness Abbey

Harper Gaythorpe, a local historian, recognised the abbey as an important part of Furness history. In this photograph he and the members of Cumberland and Westmorland Antiquarian and Archaeological Society visited the abbey for a tour. The visitors assembled on the steps at the side of the west tower to record the event. The tower was completed in 1500 so only had thirty-seven years of life before the bells were removed and the building destroyed by the King's officers as part of the Dissolution. (Harper Gaythorpe Collection, Barrow Archives)

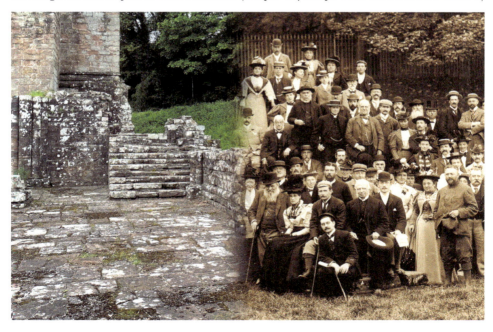

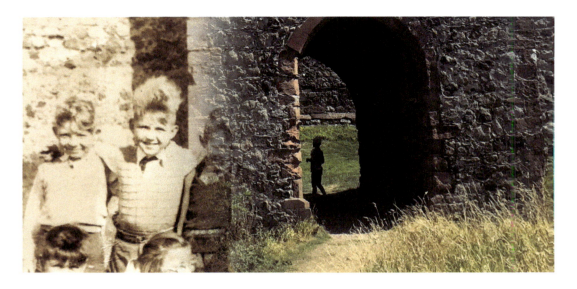

Piel Castle Gatehouse

Piel Castle is a thirteenth-century fortification built for the Abbot of Furness as a secure storage place and look-out along the Irish Sea. It was built as protection from Scottish incursions and was also a summer retreat for the abbot. The castle was briefly taken from the monks by Henry IV because of storing contraband and avoiding excise duty. The castle is a popular venue for school visits and trips and the one here shows Barrow Island School children from the 1930s. (Picture courtesy of Sarah Taylor)

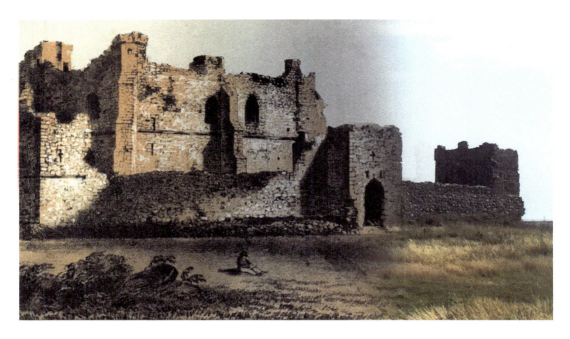

Piel Castle, Pile of Fouldray

The Pile of Fouldray as it was known played a significant role in an unlikely invasion in 1487 by Yorkists against Henry Tudor. A boy of ten, Lambert Simnel, was the figurehead, pretending to be Edward Plantagenet, Earl of Warwick. He arrived with troops from Ireland led by Martin Swartz and Lord Kildare, and they were joined at Piel by some English supporters. The rebellion was crushed at the Battle of Stoke and the leaders executed. Lambert was spared and worked in the royal kitchens, eventually rising to the status of a falconer. This story led to a ceremony to crown the 'King of Piel' when each new publican takes over the hostelry.

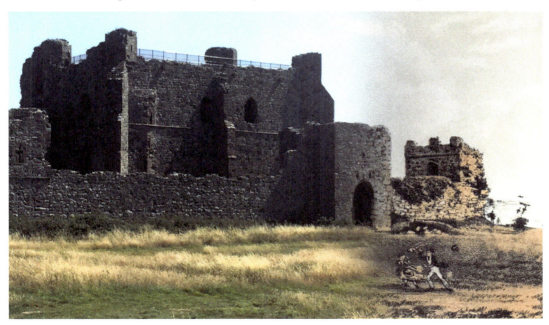

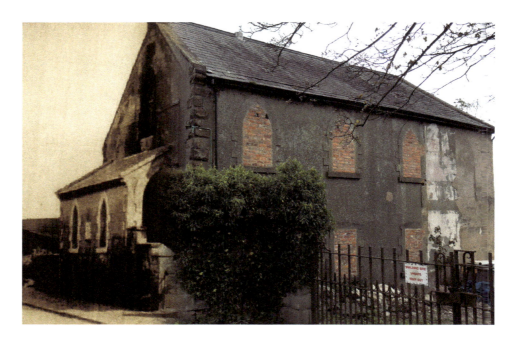

Roose Methodist Chapel, Stonedyke

Roose developed as a village in the nineteenth century when sandstone houses were built for the Cornish miners who arrived to work in the iron ore mines. The miners brought with them methodism and their own religious traditions. This small chapel was built to allow the miners and their families to worship in their own way. Further into the village was a mission church again reflecting the Cornish traditions, being named after the Cornish patron saint Piran or Perran. The chapel fell into disuse and amalgamated with the mission church in recent years, but that too has now gone and with it the memory of these early worshippers. (Photo courtesy of Barrow Archives)

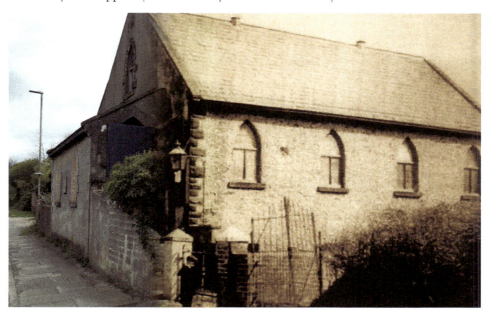

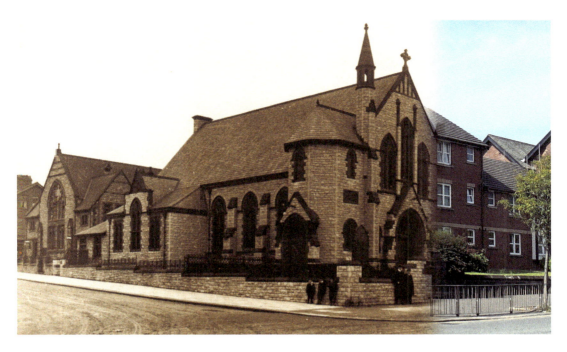

Emmanuel Congregational Church, Abbey Road

With the influx of people from other places, new churches of various denominations grew. Emmanuel Congregational Chapel was established on Ainslie Street in 1876 and then extended in 1900. It became the home for the Hindpool Congregationalists too and continued until 1991, when faced with huge repair costs which saw its closure. The congregation moved to share Abbey Road Methodist Church and this church is now known as Trinity Church. The original church was demolished and replaced by flats for the elderly. (Photo courtesy of Barrow Archives)

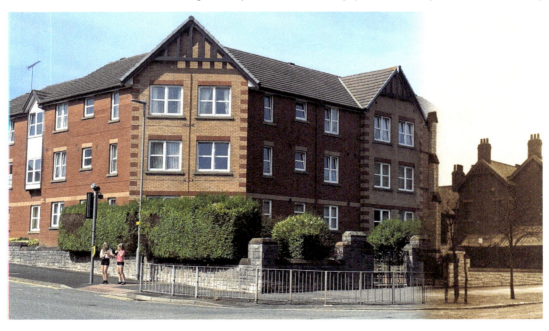

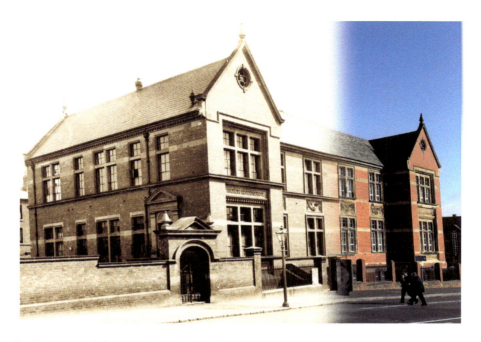

Alfred Barrow Higher Grade School, Duke Street
Lady Cavendish laid the foundation stone in 1888. The Higher Grade School provided higher education for 1,200 pupils; it was the only high school at this time. Later it became a boys' and girls' school, and the older building was for the girls. In the 1950s and 1960s the boys' school was removed to the Holker Street site. In the 1970s it became comprehensive and once again had both genders on-site. Despite major campaigns and the final headteacher bringing the school out of special measures, the county council closed the school in 2009. The pupils were dispersed to the new Furness Academy. Alfred Barrow School is now a state-of-the-art health centre and has been a lynchpin of the mass vaccination strategy for Covid. (Photo courtesy of Barrow Archives)

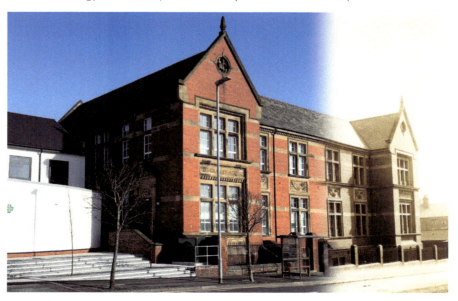

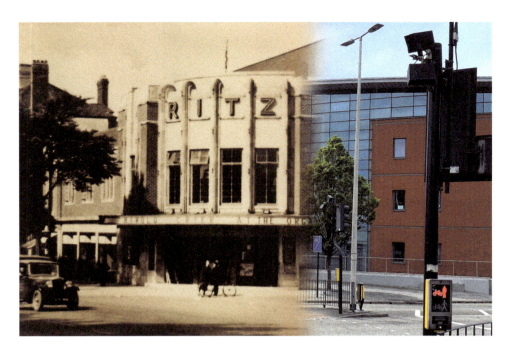

The Ritz, Abbey Road
The corner of Abbey Road and Holker Street housed a popular cinema built in 1936. It was a lovely art deco building and had a restaurant in its early days. The Ritz became the ABC after the Second World War, and gained a place in people's hearts – which one of us can't recall queuing around the outside of the building when a new film was released? It was called the Apollo during its last incarnation but sadly, it became dilapidated and finally it was demolished and a new multi-plex was built at Hollywood Park.

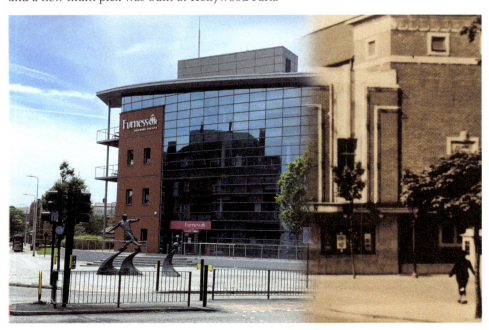

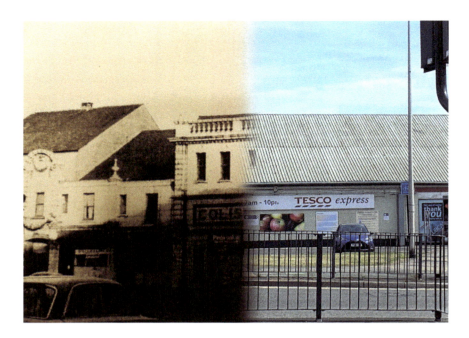

The Coliseum, Abbey Road

One of the most attractive theatres was the Coliseum, which dominated the corner of Abbey Road and Rawlinson Street, facing the Ritz and opposite the Duke of Edinburgh. It replaced the wooden-built Hippodrome which was destroyed by fire and was opened in 1914. It combined cinema and live theatre and was taken over by various cinema chains three times, finally by the Essoldo chain in 1948. It was closed in 1964 and like the Ritz it was sadly demolished in 1977. It was a great place for entertainment and generations of children enjoyed the rowdy pantomimes. Its replacement is less edifying being a car park and grassed area.

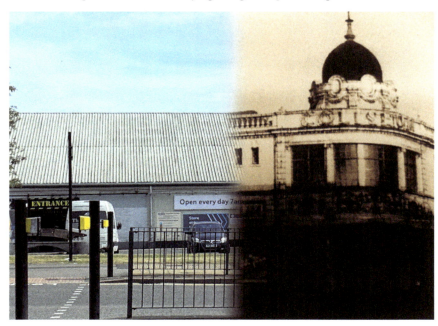

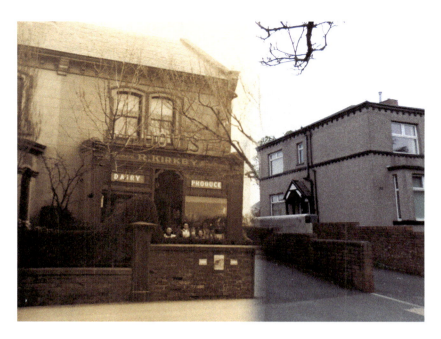

Alexandra Villas, Abbey Road

These Victorian 'villas' were built in 1877 when Barrow was in the ascendent, and a growing middle class wanted accommodation commensurate with their social and economic position. They are placed along the main approach road to the town but are away from the workers' terraces and industry. Barrow Lane, as it was known, was straightened and widened to ensure a grand entrance to the town was achieved. The building in both photos has a commercial purpose, changing from grocer to photographer, but next to residential homes. (Photo courtesy of Barrow Archives)

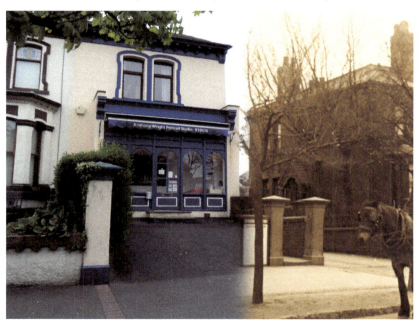

63

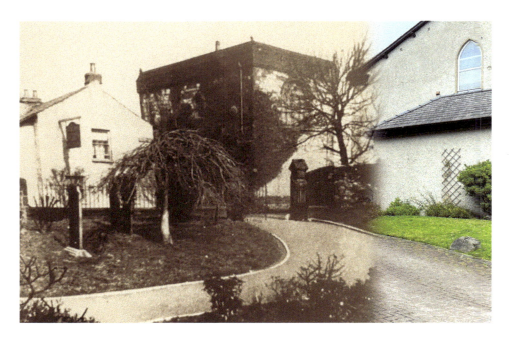

Dalton Castle

The Pele Tower was built following the Great Raid by Robert the Bruce in 1322 – it is likely that it replaced an earlier version of defence. It was under the administration of the Abbot of Furness and became the judicial centre and had prison, pillory and gallows for those who had committed offences. It is simple in design but has been altered many times. It was repaired using stone for Furness Abbey in 1546 under the instructions of Henry VIII. It was originally four storeys but was changed to two and extensively altered by the Duke of Buccleuch in the nineteenth century. It now houses a small museum and is under the protection of the National Trust.

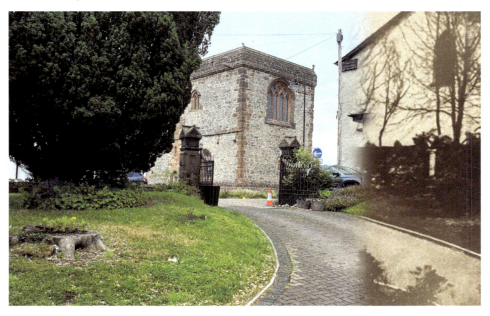

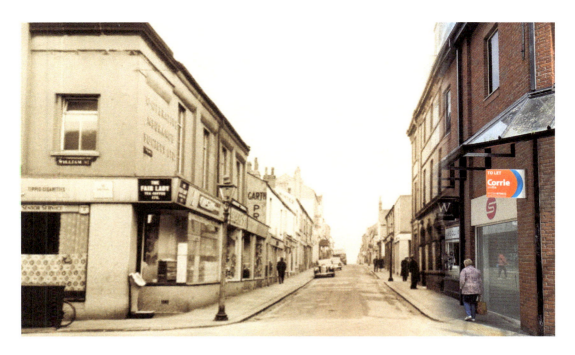

Forshaw Street
It is very difficult to see any evidence of Forshaw Street and make a proper comparison. Most of it is now beneath Portland Walk, a relatively new shopping street. So, the position of the old street is partly guesswork and partly memory. Forshaw Street was full of small shops such as Winters, Ashcrofts butchers, Quigleys Toy Shop and public houses like the Mason's Arms. The new street has a declining number of shops and outlets, which is a worrying trend exacerbated by the impact of the pandemic. (Photo courtesy of Barrow Archives)

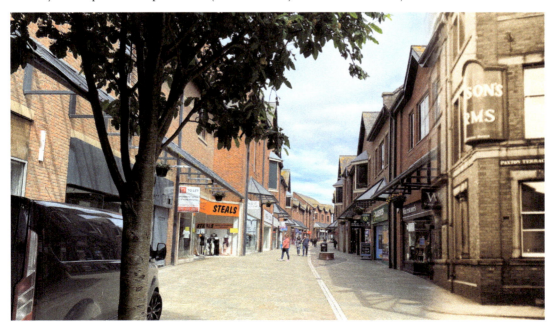

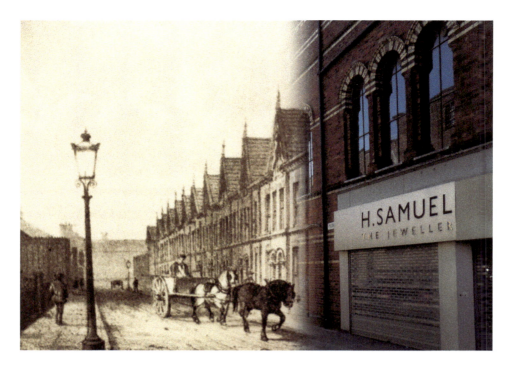

Preston Street
Again, due to huge changes in the town Preston Street is only a shadow of its former self. The terraced street was extensive but has now been virtually obliterated by the Portland Walk scheme. The only original buildings are those which house Samuel the Jewellers. The Working Men's Club replaces the older houses, and the street then disappears into a loading area.

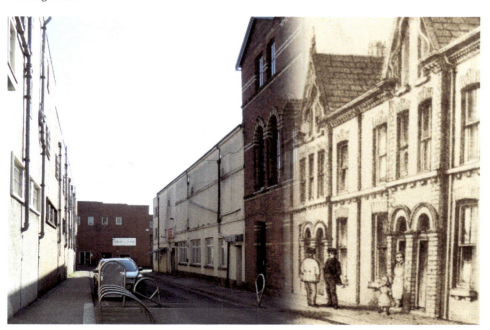

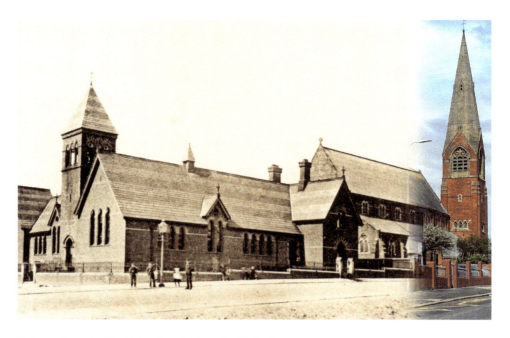

St James' CE Junior School and Church, Blake Street
The site for the church and school was donated by the Duke of Devonshire and they were built in response to the rapidly rising population. The Directors of the Iron and Steel Works funded the buildings and Paley and Austin designed them, the church being consecrated in 1869. The school had been opened two years earlier in 1867 and was used for worship until the church was completed. The church has undergone restoration in recent times, but the Junior School has been demolished and replaced by a modern building. (Photo courtesy of Barrow Archives)

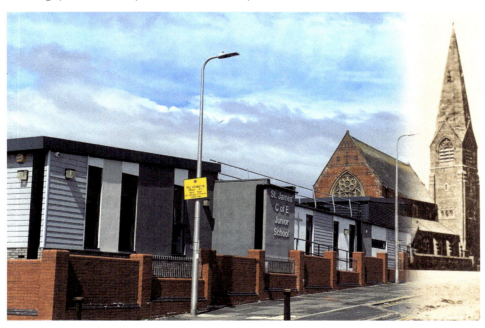

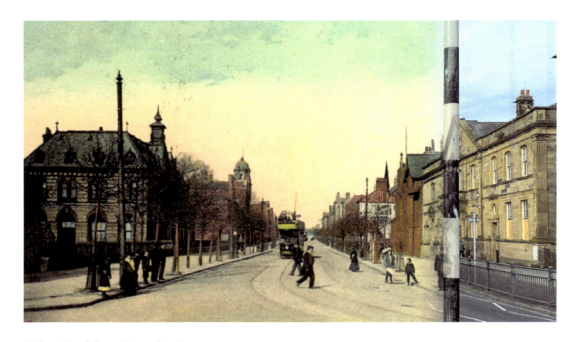

Abbey Road from Ramsden Square

Tramlines are visible in this colourised postcard and the wide Abbey Road opens onto Ramsden Square. On the left we can see the House of Lords public house as it once was, a grand Victorian building which was originally a working men's club built in 1871. It became a public house called the Lord's Tavern and later, the House of Lords. Sadly, it was burnt down after years of neglect and vandalism in 2017. As a listed building the façade was saved, but its future is still uncertain.

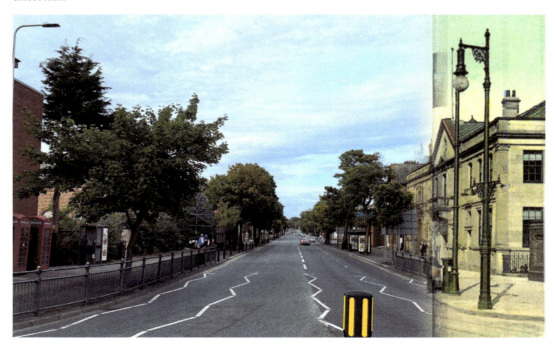

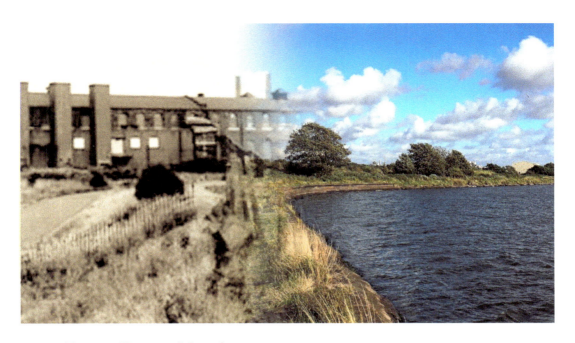

Salthouse Mills, Cavendish Dock

Diversification of industry was an obvious development for the town and Salthouse Mills was established in 1888. It was a large employer of women and there are some remarkable photos by Sankey of the early period of this factory. In 1919 it became Barrow Paper Mills, enduring until 1972. Its demise was keenly felt in the town as it had provided reasonably well-paid employment. It is now derelict apart from a few small workshops for small businesses. Its future is about to change dramatically as it is primed for a huge redevelopment scheme. (Photo courtesy of Jennifer Foote)

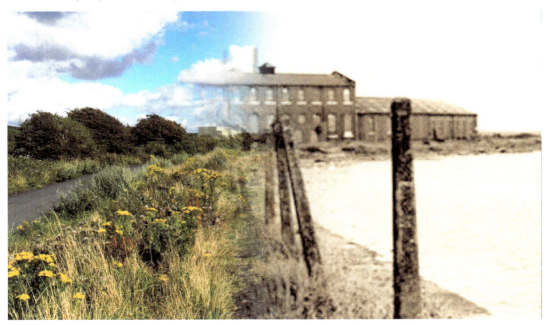

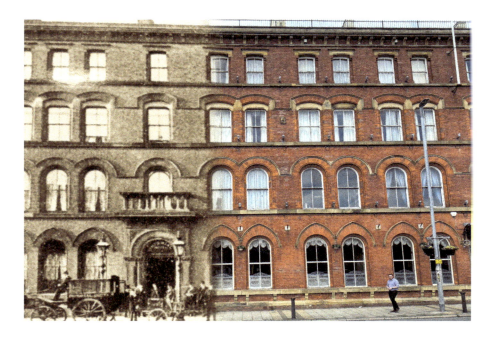

The Imperial Hotel, Cornwallis Street
Based on the notoriously named 'Gaza Strip', The Imperial has had a long history and outwardly has weathered the time well. It was built in 1875 and made from sandstone and red brick in a prestigious position near to the town hall. There are various original features which remain, such as the balconies and the lamps (originally gas light), and it retains its Gothic appearance. It is still a hotel and bar and was renovated extensively in 2012. The building is Grade II listed and the whole street has interesting buildings, some of which are not as well cared for as the Imperial. (Photo courtesy of Barrow Archives)

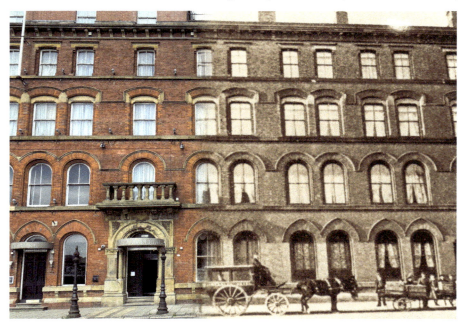

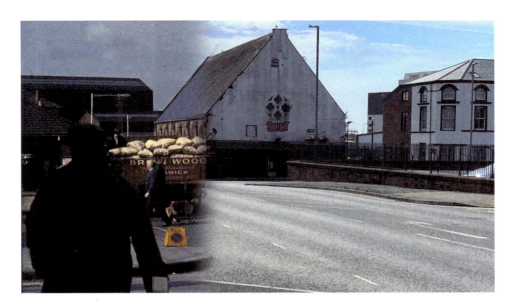

The Covered Market, Market Street

Barrow boasted a large indoor and outdoor market which attracted shoppers from all the outlying districts. It had a typical glass and iron canopy and a myriad of stalls. Yet another venture instigated by James Ramsden to further develop the town, the market was begun in 1864. Again, Paley and Austin played a great part in the market hall's development and in 1903 a fish market was added. The old market was demolished, and a new brutalist building replaced it on the site of Paxton Terrace in 1971. Market Street has changed much over recent years and the only constant is the town hall. (Photo courtesy of Barrow Archives)

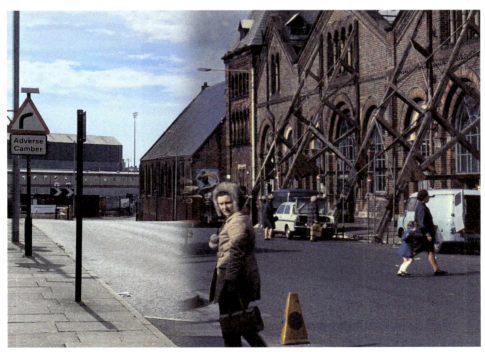

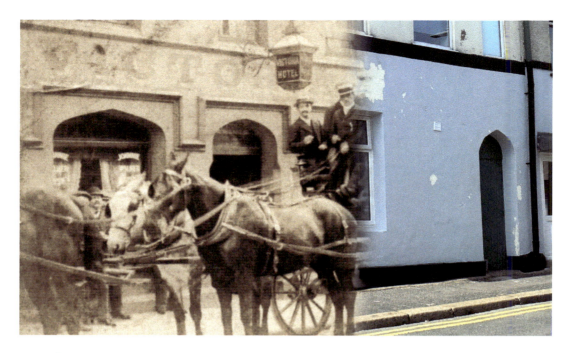

The Victoria Hotel, Church Street

Barrow had many public houses for the benefit of the workers and visitors to the town. The Victoria Hotel was a pub and eating-house and offered rooms for guests. It had visitors from far and wide according to the 1881 census. It was in a prominent place in town and was busy. The publicans then were Charles and Mary Jane Bleasdale. They also ran the Ormsgill Hotel (with a bowling green no less) and were present at the start of Barrow's growth. The pub was restored but then was closed again recently. It is now being converted into residential accommodation.

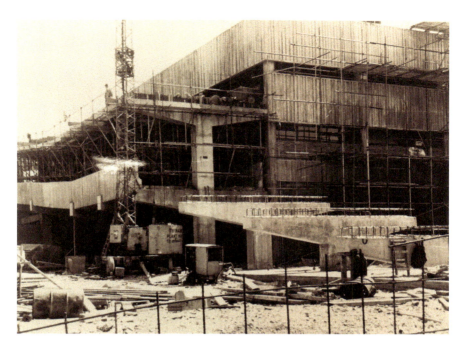

The Civic Hall
Brutalist architecture was popular in the 1970s and the market hall and performance space was built in the place of the old Paxton Terrace and to replace the old market. Naturally, to fit with modern needs a multi-storey car park was built above the Forum theatre and market hall. It endures (sadly some would say) but has had tweaks here and there so it does not dominate quite as much. The picture shows its construction and emphasises its incongruity against the beautiful town hall opposite. (Photo courtesy of Barrow Archives)

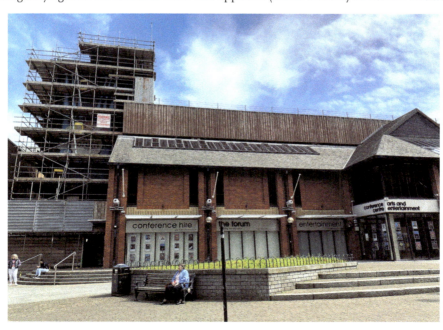

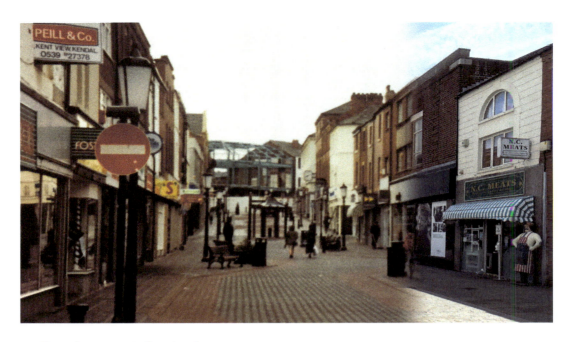

Marks and Spencer, Dalton Road

Established in 1911, Marks and Spencer were a mainstay for years in Barrow's main shopping street. It grew over time and was relocated to Dalton Road, selling food and clothing. It unfortunately declined in the twenty-first century and became one of the stores to be closed in 2020. A new store was opened in a retail park on the edge of Ulverston and many of the staff were redeployed there. It leaves a huge gap and heralds even more retail outlets leaving the town, like Debenhams, WHSmith, and River Island. (Photo courtesy of Barrow Archives)

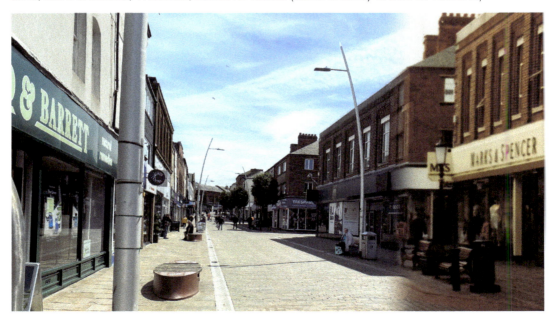

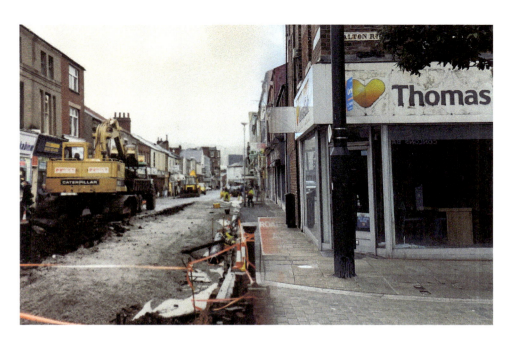

Cavendish Street
Always a busy street, Cavendish Street held some great small shops and cafes. It crossed Dalton Road and provided a huge variety of shopping opportunities. Pedestrianisation began in the 1980s and again in the 1990s, when paving was replaced and the gazebo removed. It was designed to enhance shopping and make the access easier, but now it almost seems irrelevant as the town is declining. Lots of small businesses are dotted about the side streets and are thriving; the issue is the larger outlets have vanished very quickly and the task to revive the town is an uphill battle. (Photo courtesy of Barrow Archives)

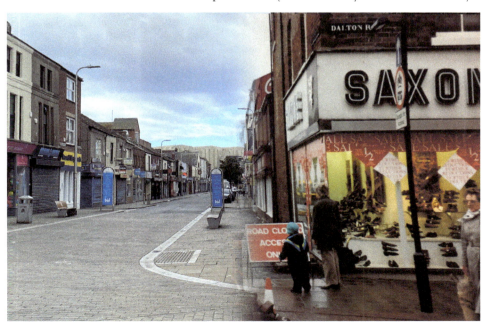

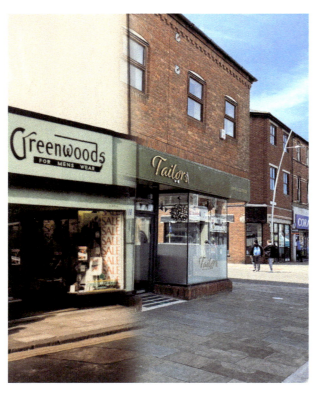

Greenwoods, Dalton Road

This was a popular men's outfitters offering the more traditional items including trilbies, cufflinks and handkerchiefs. The shop was part of the scenery for years and it was perhaps because it had not adapted to keep up with the times that it closed. It has been replaced by a restaurant called Tailor's Bar and Lounge, the name giving a nod to its previous incarnation. (Photo courtesy of Barrow Archives)

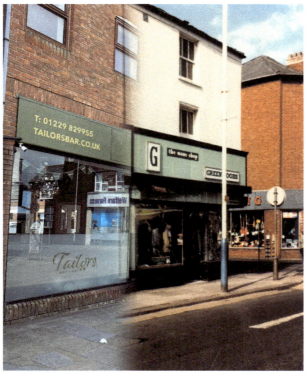

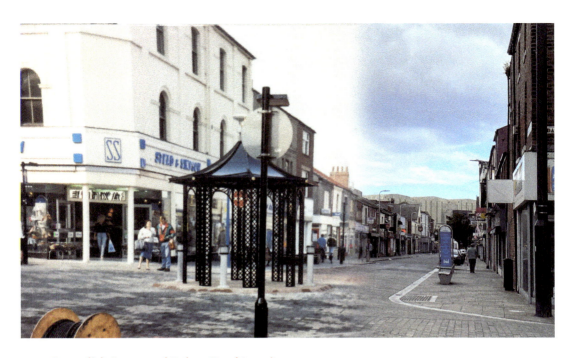

Cavendish Street and Dalton Road Junction

Another view of upgrading work to the pedestrianisation in this area shows two key shops which have also disappeared. Saxone and Stead and Simpsons were large, well-stocked shoe shops and many of us can remember having feet measured on the rabbit chair at Saxone. Both shops have gone, and the prime corner position has been replaced with a charity shop and a travel agent (but this too has gone now). (Photo courtesy of Barrow Archives)

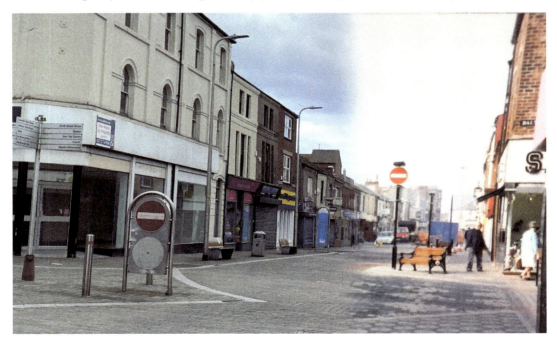

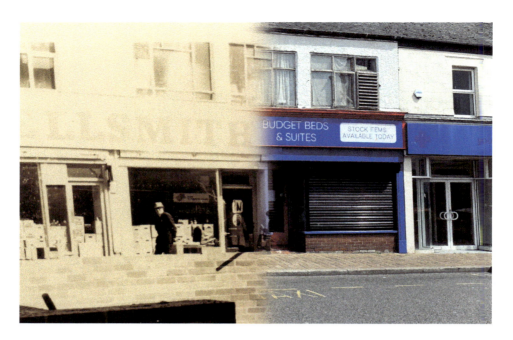

Dalton Road (top)

We can see here earlier changes to the street: modernising it and offering seating and safe, pedestrianised shopping. The two shops in the background are gone and show yet more decline in the town. The top end of the road has banks and other commercial premises changing from shops and retail outlets. This again reflects the different ways the shopping street is altering and providing different establishments. (Photo courtesy of Barrow Archives)

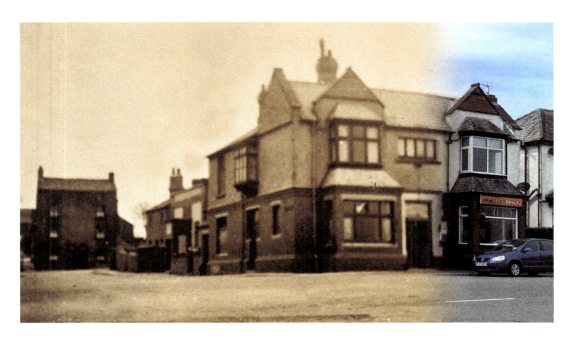

The Bay Horse, Hawcoat

Public houses have developed over the years, and it is harder for them to thrive these days. Bass Charrington established the first Bay Horse on the site of a sub-station, but this was too small. The Bay Horse then moved into the building in the picture, but later moved across the road into a larger building. However, the second building now houses Paul French hairdressers and beauty salon. The interior obviously has undergone change, but the exterior is still recognisable. (Photo courtesy of Barrow Archives)

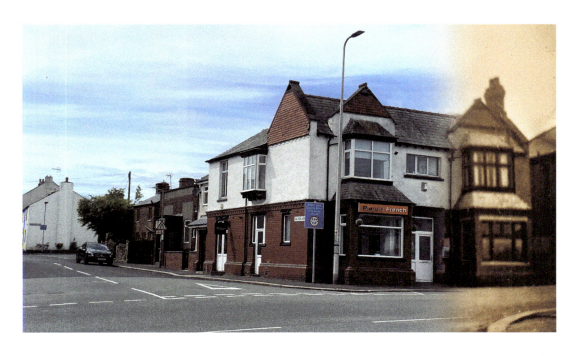

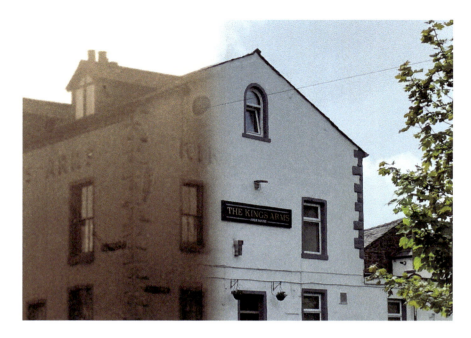

Kings Arms and Hawcoat

Mentioned in the Domesday Book, Hawcoat, or Hietun as it was known, has been constantly inhabited since then. It was part of the Manor of Hougun under the lordship of Earl Tostig, the brother of King Harold. It was one of the larger settlements after Dalton and now has a huge residential estate covering what was farmland. The village is at the heart of this estate and has some interesting features such as the Memorial Hall, How Tun Woods and the older cottages tucked away on Roanhead Lane, some built as early as 1716. The Kings Arms has endured and was in preparation for the Platinum Jubilee for Elizabeth II when the current picture was taken. (Photo courtesy of Barrow Archives)

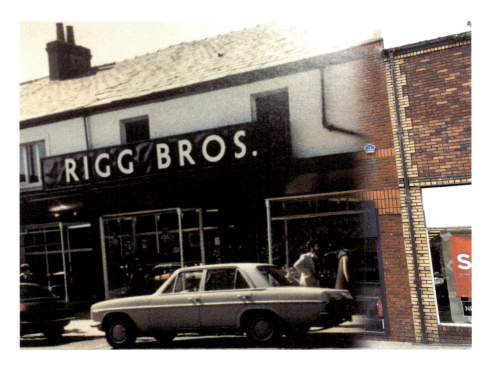

Rigg Bros, Shoe Shop, Dalton Road

Another iconic shop at the top of Dalton Road was Riggs. They were vendors of superior footwear and stocked notable lines like 'Jumping Jacks', and Clark's shoes. It was a family business and was an important outlet. As time went on more shoe shops arrived, some offering cheaper options, and Rigg Bros eventually closed both the Barrow and Ulverston branches in 2010. (Photo courtesy of Barrow Archives)

Franchi's, Dalton Road
Numerous Italian immigrants arrived in Barrow in the late nineteenth and early twentieth centuries and set up businesses as purveyors of ice cream. Franchi was one of these families and their brand and name was well known. They had a couple of outlets, this one being in Dalton Road. (Photo courtesy of Barrow Archives)

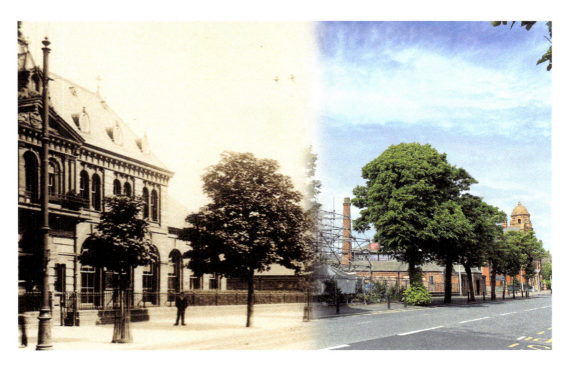

The House of Lords, Abbey Road
It is a very sad comparison in these two photographs – the building is a mere shell of its former self. One wonders whether it might not be better to demolish it completely instead of displaying its raddled bones to the public gaze. It does no favours for the surrounding architecture and is a poor first glimpse of the square, which I am sure Ramsden would deplore. When you see the postcard image it is very sad to note the vibrancy and the neatness, long gone.

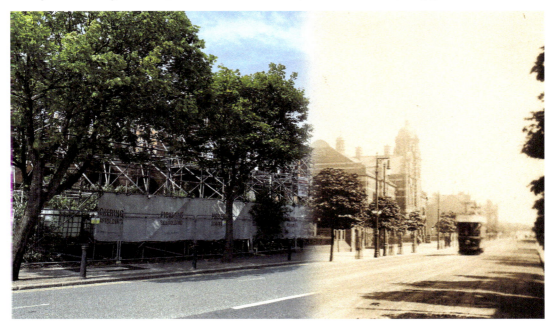

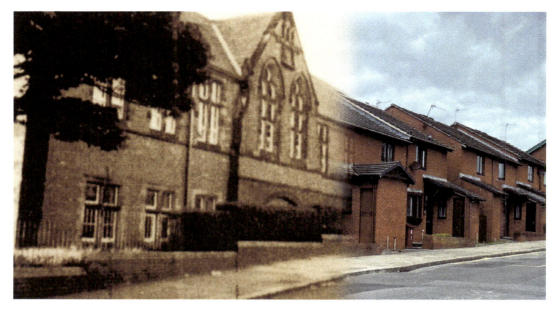

Victoria Junior School, Oxford Street

Schools are at the forefront of change, and we have seen many Victorian and Edwardian buildings bite the dust, often in preference for modern box-like structures. Some have survived, some have not; Victoria Junior School, built in 1884, did not survive. The school was demolished in 1976 and later replaced with housing. The school was relocated to Devonshire Road with a modern building and plenty of outdoor space and playing fields. (Photo courtesy of Barrow Archives)

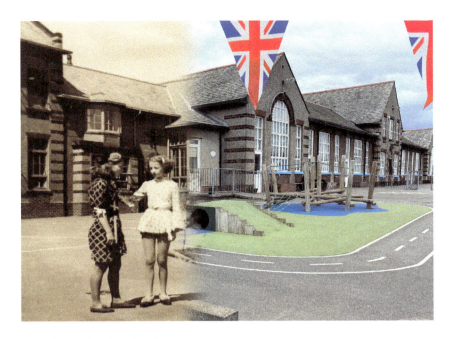

Victoria Infant School, Oxford Street

Built in 1917, this school has survived the ravages of time. It is a traditional style, corridors running off a central hall at the rear. It has adapted and been added to according to the needs of the time, including a reception, nursery and extra classroom to provide for all early years and key stage one children. The photo shows girls from the senior school located behind the infants', practising for a play. A celebration for the Queen's Jubilee is evident by the bunting and flags in the recent photograph. (Picture courtesy of the late Joyce Fitzsimmons)

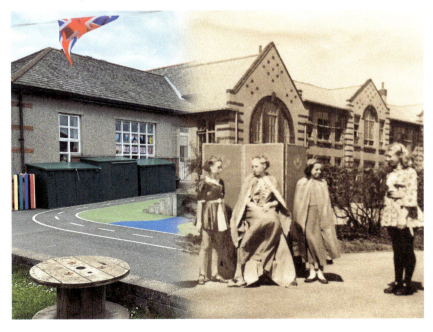

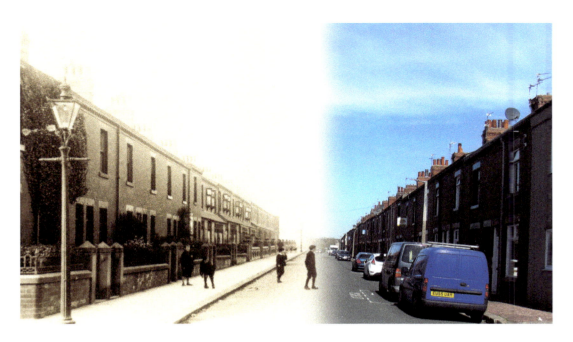

Devon Street

There are many examples of artisan terraced houses in Barrow, but Devon Street is very well preserved and has hardly changed at all. The housing is different on either side of the street. One side has simple terraces opening directly onto the street, very simple and plain, whereas the other side has houses with small front gardens. These differences were evidence of the hierarchy even among the working class: gardens were often reserved for the blue collar workers or overseers, whereas the manual labourer would have a house with only a backyard. (Photo courtesy of Barrow Archives)

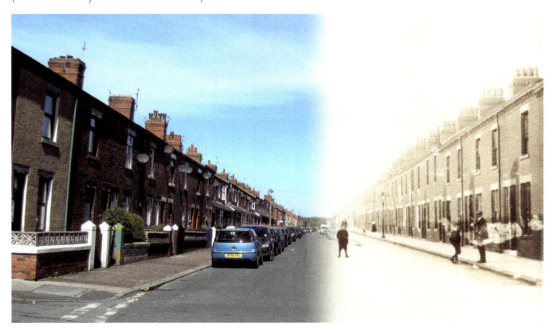

Middle Hill, Newbarns

In the post-war years there was a great need for housing and the country embarked upon a programme of construction. This area of Newbarns was designated as prime building land for social housing. These were houses with all modern conveniences, for families especially, and there was attention paid to green areas and trees, an estate with wide roads and convenience stores. This estate is still very popular but many of the houses are now privately owned and is still a pleasant place to raise a family. (Photo courtesy of Barrow Archives)

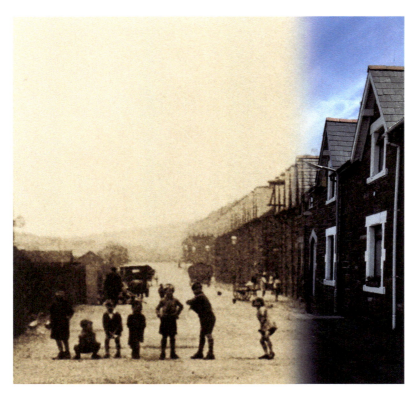

North Row, Roose

In the 1840s iron ore was discovered in the Furness area and this brought an influx of people to work in the mines. The mining company built the sandstone terraced cottages for the miners, most arriving from Cornwall, where the tin mines had failed. The village had a rail link to the mine, and it became a thriving settlement. St Perran's Church was built, and the Methodist chapel at Stonedyke for the Cornish miners to use and many local names still reflect the ancestry of the miners. The village has expanded and sits between Holbeck estate and Balmoral estate, both offering more modern homes.

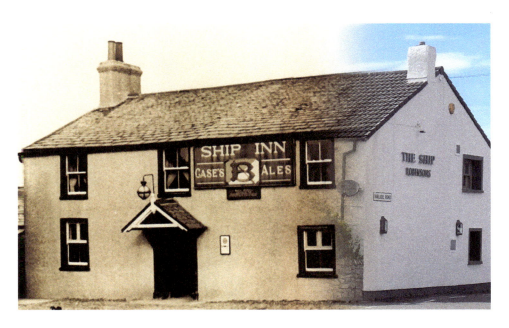

The Ship Inn, Yarlside Road

Originally a farmhouse, the Ship Inn became a beerhouse, probably when the mining brought in more people. It is a well-supported pub and restaurant today but has undergone many physical changes. In the 1960s it gained a lounge bar or snug and was demarcated into the 'best end', where mixed company drank, with bar at the back. After changing hands in 2005 it was refurbished and made into a family pub, and the frontage was improved and a wall built around it. Some of the old patrons mourn the loss of the bar, but it still retains its popularity. (Photograph courtesy of Noah Jepson)

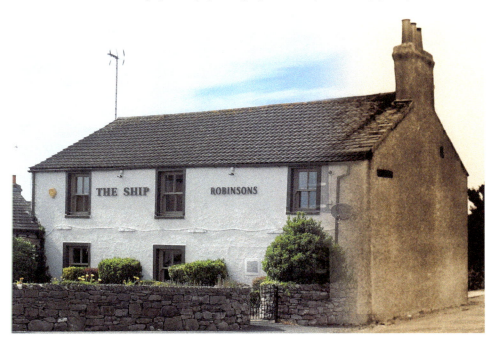

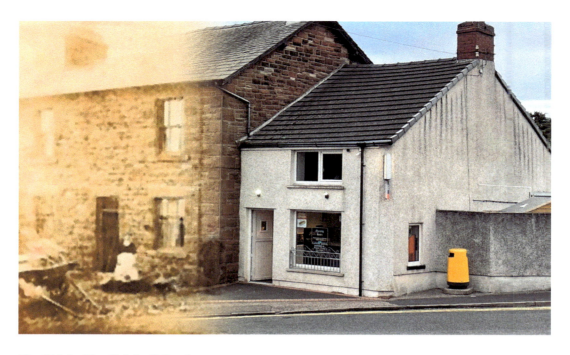

The Old Smithy, Holebeck Road
The sandstone construction of this building is typical of the area and its origin as a blacksmith is reflected in its name. The building has retained some features, but part of the original smithy has been lost. It is now a thriving fish and chip shop and has a good position on the roadside, just as its predecessor did. However, unlike the smithy, the chip shop attracts a lot of traffic and parking issues despite the efforts of the owners to alleviate this by opening an outdoor seating area for customers behind the building. (Photos courtesy of Barrow Archives and Nathaniel Jepson)

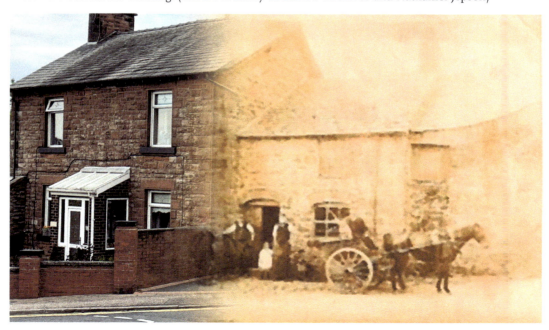

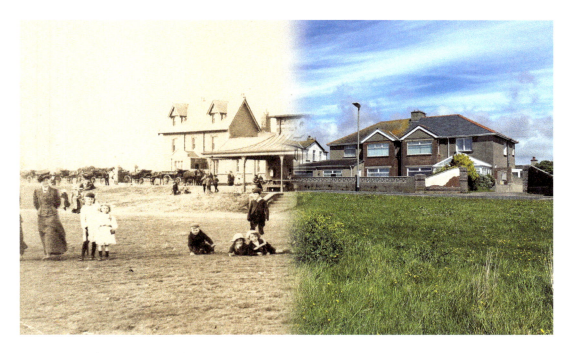

The Pavilion, Biggar Bank
No trace of this building exists today, but some of the older generation can remember it still being there in the 1960s. Biggar Bank was and still is a popular summer venue and in its earlier days it had some features to encourage visitors, such as the pavilion. It provided some facilities, such as refreshments and toilets and shelter and was a popular feature and a landmark. There is no physical trace of the building now but its location was near to the Castle House Hotel which gained a liquor licence in 1950. (Photo courtesy of Barrow Archives)

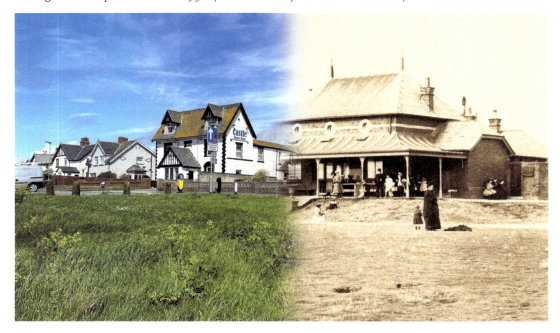

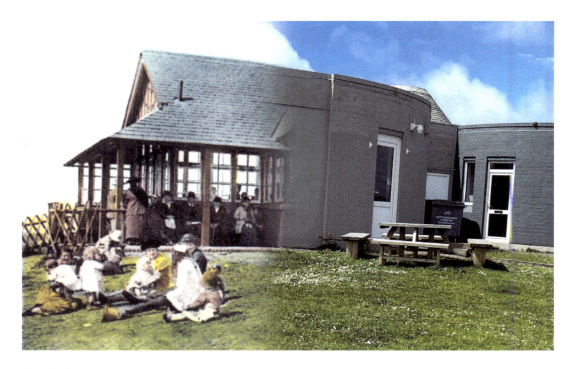

The Shelter, Biggar Bank
Not as grand as the Pavilion, the Shelter was provided for those who wished to avoid the sun (or wind as was often the case). This too has disappeared and was approximately where the Round House is now. The concrete building has its own appeal but is perhaps not quite as attractive as the old shelter. (Photo courtesy of Barrow Archives)

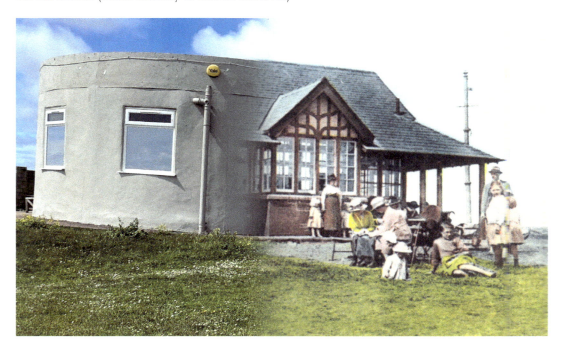

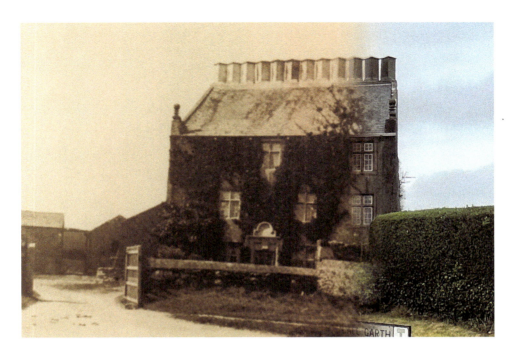

Rampside Hall
This amazing Grade I listed building stretches back to the seventeenth century. It was built for the Knype family on the site of an earlier house. Its nickname 'The Twelve Apostles' comes from the impressive twelve chimneys it displays. The house has had some alterations and repairs were required to three of the chimneys in 1865 when they were toppled during a small earthquake. It stands proudly facing the sea, slightly incongruously surrounded by a modern street and housing. (Photo courtesy of Barrow Archives)

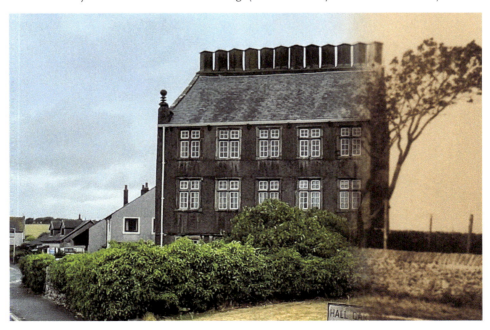

Secret Barrow-in-Furness